PITTSFIELD'S
FOSBURGH
MURDER
MYSTERY

To Kim —
I hope you enjoy the
book. Thank you for your
support !
 All my best,
 Frank Leskovitz

PITTSFIELD'S
FOSBURGH
MURDER
MYSTERY

SCANDAL IN THE BERKSHIRES

Frank J. Leskovitz

FRANK J. LESKOVITZ

THE
History PRESS

Published by The History Press
Charleston, SC
www.historypress.net

Front cover images from the personal collection of Beatrice Lynn Wilde.
Back cover images from the author's personal collection.

First published 2016

Manufactured in the United States

ISBN 978.1.46711.827.9

Library of Congress Control Number: 2015956013

Notice: The information in this book is true and complete to the best of our knowledge. It is offered without guarantee on the part of the author or The History Press. The author and The History Press disclaim all liability in connection with the use of this book.

This book is dedicated to the memory of Miss May Fosburgh. So sweet was her music—and so tragic that it ended so soon.

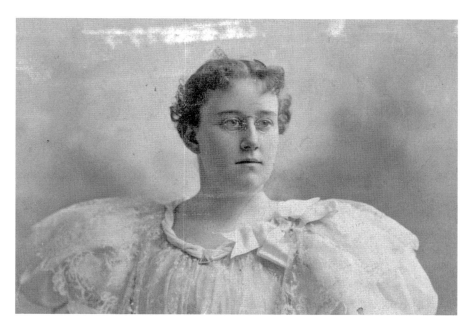

May Lydia Fosburgh. *Photograph from the personal collection of Beatrice Lynn Wilde.*

Piano

Softly, in the dusk, a woman is singing to me;
Taking me back down the vista of years, till I see
A child sitting under the piano, in the boom of the tingling strings
And pressing the small, poised feet of a mother who smiles as she sings.
In spite of myself, the insidious mastery of song
Betrays me back, till the heart of me weeps to belong
To the old Sunday evenings at home, with winter outside
And hymns in the cosy parlour, the tinkling piano our guide.
So now it is vain for the singer to burst into clamour
With the great black piano appassionato. The glamour
Of childish days is upon me, my manhood is cast
Down in the flood of remembrance, I weep like a child for the past.

D.H. Lawrence

CONTENTS

Comments and Acknowledgements

The story that follows deals with one of the most sensational murder mysteries in Massachusetts history. It still remains unsolved today.

One of the hardest parts of dealing with such a newsworthy murder case in which all the major players are long dead is sorting out fact from fiction. While I believe I've done a decent job of it, any errors within are mine and my responsibility alone.

Some words in the story are used interchangeably. An example of this would be nightgown and night dress. Another would be pistol, gun and revolver. The last name Fosburgh was very occasionally written as Fosburg in the press. I use Fosburgh throughout the book for consistency. This is how the name is spelled on the family grave markers, as well as the United States census data of the era. Robert S. Fosburgh's middle name, Stuart, was frequently written incorrectly as Stewart. (Stuart was his mother's maiden name.)

Newspaper accounts figured significantly in this case, and I relied heavily on vintage accounts given in both the *New York Times* and the *Berkshire Evening Eagle* of Pittsfield, Massachusetts.

During the course of the trial, many questions were asked that may lead the reader to additional questions that unfortunately were never asked or clearly answered. I share in the reader's frustration.

A "Cast of Characters" is included in the back of this book as an aid for the reader to keep track of the numerous individuals mentioned within.

Even when there are obvious errors in the testimony of individuals, I have left them as found. I have reached some personal conclusions about

this sad tragedy, but I'll leave it entirely to the reader to sort it out and to reach his or her own conclusion. I would love to hear your opinion at fleskovitz@gmail.com.

Special thanks to all those who work at the Berkshire Athenaeum, Pittsfield's fine public library. The library here has been a large part of my life since childhood. I would like to acknowledge the excellent assistance that I received there from Ann-Marie Harris and many others in the local history department.

I would like to acknowledge the assistance of Beatrice Lynn Wilde, the granddaughter of Beatrice Fosburgh, who aided me in confirming Fosburgh family history and generously shared photographs from her personal collection. Thank you, Lynn.

Thank you to Maryann Byrnes for taking numerous helpful photographs at the Fosburgh family plot at Woodlawn Cemetery in Bronx, New York.

Additional thanks to Lowell Paddock and Christine Paddock Foster for sharing information about their great-grandfather Dr. Franklin Kittredge Paddock.

I particularly value the input and clarifications that I received from several knowledgeable individuals who wish to remain anonymous. Your contributions are forever appreciated.

Valued thanks go to Tabitha Dulla for giving me the "spark" to write this story of the tragic death of Miss May L. Fosburgh.

Special gratitude goes to Elizabeth Farry and Karmen Cook, my editors at The History Press.

I would also like to thank the Pittsfield Police Department, Pittsfield City Hall, Pittsfield Cemetery and the Berkshire County Superior Court.

And finally, I especially would like to thank my family for all their love and support. I couldn't have done this without them.

A Murder in Pittsfield, Massachusetts

The small city of Pittsfield, Massachusetts, is centrally located in the Berkshire Hills of Western Massachusetts. The land encompassing Pittsfield was originally known as Pontoosuck, which is said to mean "a field or haven for winter deer" in the Mohican language. In 1761, the area was incorporated as the Township of Pittsfield. It was named after British politician William Pitt, who would eventually serve as the prime minister of Great Britain. At the time of incorporation, some 200 residents had settled in Pittsfield. After the Revolutionary War, the population grew to nearly 2,000 residents. Agriculture was the major focus in those early years. Abundant water from the Housatonic River and other sources served to attract industry to the area. These new mills produced lumber, grist, paper and textiles. Pittsfield would quickly become one of the major woolen manufacturers in the United States. By the late 1800s, the town was flourishing and would officially incorporate as the City of Pittsfield in 1891. Pittsfield eventually became the county seat and today is the largest community in Berkshire County. By 1900, the bustling city boasted a population of 21,766, which continued to increase with each passing day. (This number would peak at around 58,000 in 1960 and then gradually decrease to around 45,000 residents today.) The year 1900 began with the celebration of a new century—one in which it seemed new inventions and opportunities were being created every day. It was a time of great progress for both the area and the nation.

The last quarter of the nineteenth century, the American "Gilded Age" was a time of unprecedented growth and possibilities. (The Gilded

Photograph by Frank J. Leskovitz.

Age would also signify social conflict and a growing disparity between the rich and poor, particularly for newly arrived European immigrants.) The Berkshires quickly became a favorite summer destination of the rich and famous, much like Newport, Rhode Island, and Bar Harbor, Maine. Both Lenox and Stockbridge, Massachusetts, saw a great influx of New York's and Boston's most privileged society members, as well as those in the arts, particularly writers. They were drawn to the area by the beautiful scenery and pleasant summer weather. Many magnificent Berkshire "cottages" were constructed during this period. Today, the Berkshires remain very popular with tourists and artists alike.

Sunday, August 19, 1900, was a typical summer day in Pittsfield. Windows were open in hopes of catching a breeze to relieve the late summer humidity. In the quiet Morningside neighborhood, a few residents sat out on their lawns or porches. That evening, several neighbors were treated to the sound of piano music and song coming from the Castle Home on Tyler Street, one of the finer properties in the area. The sweet sounds carried like a serenade throughout the neighborhood.

The home was within sight of the new Stanley Electric plant. William Stanley Jr. had developed the first reliable transformer and became a pioneer in modern alternating current power distribution. After a break

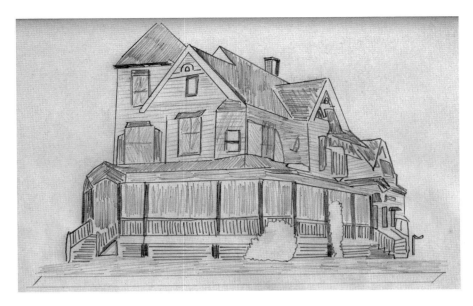

The Castle Home, Pittsfield residence of the Fosburgh family. *Author's rendering.*

with inventor and industrialist George Westinghouse, Stanley brought his research and development talents to Western Massachusetts. The Stanley Electric Manufacturing Company moved to Pittsfield from Great Barrington, Massachusetts, in 1890 and quickly became the largest employer in the city. At the time, Stanley specialized in transformers, electric motors and appliances. The very first poly-phase, alternating current generator installed in this country for power transmission was produced in Pittsfield. To this very day, all alternating current transformers are based on Stanley's designs.

The rapid growth of Stanley's business required the construction of a manufacturing plant of a size unprecedented in Pittsfield. A site was selected in the Morningside neighborhood along the rail lines. Many in Pittsfield were greatly relieved by Stanley's continued commitment to the area.

The Stanley Works contributed greatly to the birth of the national power grid as well as to the future growth of Pittsfield. It was written that "in the long life of Pittsfield, the city's association with Mr. Stanley was hardly more than brief and casual; nonetheless, the result was a stimulation which is not soon to be forgotten by the community."

The R.L. Fosburgh and Son Construction Company was contracted to help expand William Stanley's electrical empire. Rapid growth required the construction of new buildings. The Fosburgh firm had 270 men on

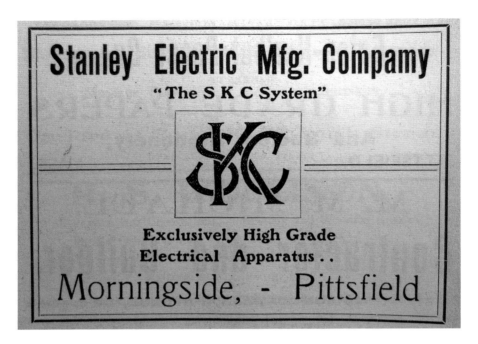

An early advertisement for Stanley Electric Manufacturing Company. *From* Pittsfield City Directory, *Eagle Publishing 1900.*

its payroll. In Pittsfield, the company hired many local laborers, primarily Italian immigrants who had come to the United Stated in search of a better life. Most worked as shovelers, excavating the foundations for the buildings to come. Fosburgh's weekly payroll at the time was claimed to be in the neighborhood of $6,000 per week—well over $160,000 in today's dollars.

In 1901, less than 5 percent of the U.S. workforce was unionized. Most people worked six days a week and at least nine hours a day. The lack of retirement benefits or health insurance meant one had to work until they had enough money saved to stop or until they died. It was a hard life in a time when men lived to an average age of just forty-seven and women to age fifty. The efforts of these hardworking immigrant laborers and craftsmen can still be seen throughout the Berkshires today, reflected in the architecture of many fine churches and numerous other impressive local buildings that still stand proudly.

The Fosburgh firm had found its own success with many construction projects throughout the eastern United States. The company had previously built the enormous Berkshire Mill No. 4 in Adams, Massachusetts, for the Berkshire Cotton Manufacturing Company, owned by the Plunkett family. President William McKinley laid the cornerstone for the mill.

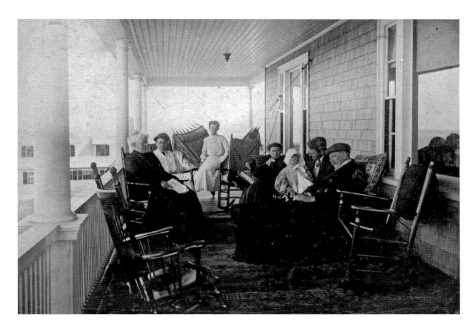

The Fosburgh family sitting on a porch circa 1904. *Left to right:* Esther Mair Stuart Fosburgh, Esther Lyall Fosburgh, Beatrice Alexandra Fosburgh, Amy Sloane Fosburgh, baby Helen May Fosburgh, Robert Stuart Fosburgh and Robert Lloyd Fosburgh. *Photograph from the personal collection of Beatrice Lynn Wilde.*

The magnitude of the expansion at the Stanley Works necessitated that the Fosburgh family relocate to Pittsfield, Massachusetts, to allow close supervision of the large project. Family patriarch Robert Lloyd Fosburgh was assisted in the construction firm by his twenty-seven-year-old son, Robert Stuart "Bert" Fosburgh. The senior Fosburgh had begun his career as a saw blade manufacturer and salesman in St. Louis, Missouri. The family rented the E.T. Castle Home, located at the northwest corner of Tyler and Woodlawn Avenue in Pittsfield. The home was a three-story wooden structure with a wraparound porch on the front and east side along with a second-floor porch. To the left was a public drinking fountain and horse watering tub, along with numerous shade trees. The house was about a three-minute walk from the Stanley Works. Living in the home with the senior Fosburgh were his wife, Esther M. Stuart Fosburgh; daughters May, Esther and Beatrice; and a son, James. James was a student at the Sheffield Scientific School at Yale University.

Eldest son Robert S. Fosburgh was married to Amy Jane Sloan Fosburgh. She had at one time worked for the Fosburgh family as a nanny to the

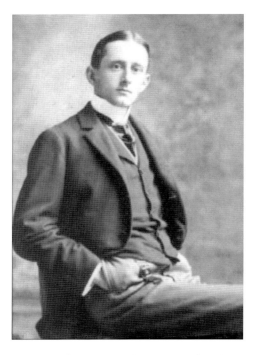

Robert S. "Bert" Fosburgh. *Photograph from the collection of an anonymous contributor.*

younger children. Amy was educated and a fine artist. Robert S. and Amy Fosburgh also resided within the household during this time period.

May Lydia Fosburgh was born on July 8, 1876, in St. Louis, Missouri, and had recently turned twenty-four years old. May had studied music in St. Louis, Missouri, and Chicago, Illinois. She was an 1895 graduate of the Buffalo Seminary, which today is New York's oldest college preparatory school for girls. Since graduation, she continued to pursue her musical studies. She often sang at the South Church in Pittsfield during Sunday services. Despite being in Pittsfield for a very short time, May Fosburgh had a wide circle of friends, thanks to "a sunny disposition and kindly manner."

A newspaper article of the era described the family:

> *The Fosburgh family are newcomers. It would be more nearly correct to say they are wayfarers in Pittsfield. They are possessors of much wealth, too, and are no more of the manner of New Englanders born than they are to the manor born. Their very action bespeaks the gentlest refinement, and, although wealthy and of aristocratic bearing, their genuine democracy and freedom from prudishness have won them friends in legion who sympathize with them and their troubles. The family resided in Buffalo and St. Louis, where they held the most enviable social positions.*

August 19, 1900, began like a typical Sunday in the Fosburgh household. Mrs. Esther Fosburgh had returned home the previous day after a visit with her family in St. Louis, Missouri. Visiting the family for the first time was Miss Bertha Louise Sheldon, daughter of a wealthy businessman from Providence, Rhode Island, and a student at Smith College. She had arrived

Esther Lyall Fosburgh, circa 1900. *Photograph from the personal collection of Beatrice Lynn Wilde.*

on August 1, 1900, and was staying in the second-floor guest room. The family attended church that morning, with the exception of Robert S. Fosburgh and his wife, Amy, who went for a drive.

Daughter Esther was away visiting the household of industrialist William B. Plunkett in nearby Adams, Massachusetts. The Plunketts were cotton mill owners and the major employer in Adams. The Fosburgh family ate dinner and then rested and chatted together on the porch until dark. Robert and Amy returned home at 6:30 p.m. That evening, upon returning inside the house, Mrs. Esther Fosburgh read to the family. May and James also took turns reading. Then Miss Sheldon played the piano while May sang several sacred songs, including "The Holy City" and Kipling's "Recessional." The final song of the evening was "The Plains of Peace," with music by D'Auvergne Barnard and words by Clifton Bingham.

The Plains of Peace

> *Is the way so dark, O wand'rer,*
> *Is the hillcrest wild and steep,*
> *Far, so far, the vale beyond thee,*
> *Where the homelights vigil keep?*
> *Still the goal lies far before thee,*
> *Soon will fall on thee the night;*
> *Breast the path that takes thee onward,*
> *Fight the storm with all thy might,*
> *Fight the storm with all thy might!*
> *Though thy heart be faint and weary,*

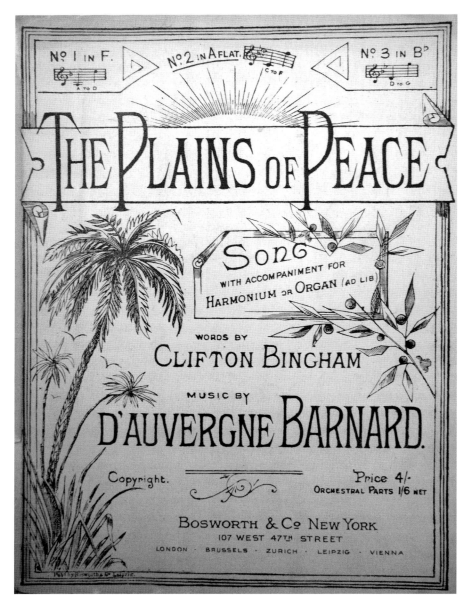

"The Plains of Peace," the final song sung by May Fosburgh the evening preceding her death. *Author's collection.*

Though thy footsteps fain would cease,
Journey onward, past the hillcrest
Lie for thee the Plains of Peace!
Though thy heart be faint and weary,
Though thy footsteps fain would cease,
Journey onward, past the hillcrest
Lie for thee the Plains of Peace!

Is thy path so rough, O pilgrim,
Passing on thy way through Life;
Deep the sorrows that beset thee,
Great the burden, wild the strife?
Though the hill of life be weary,
Though the goal of rest be far;
Set thy whole heart to endeavor,
Turn thy soul to yon bright star,
Turn thy soul to yon bright star!
From the toiling, from the striving,
There at last shall come release;
One shall bring thee, past the hillcrest,
Home unto His Plains of Peace;
From the toiling, from the striving,
There at last shall come release;
One shall bring thee, past the hillcrest,
Home unto His Plains of Peace:
One shall bring thee, past the hillcrest,
Home, Home, Home unto His Plains of Peace!

The family retired for the evening. Sunday, August 19, 1900, would be twenty-four-year-old May L. Fosburgh's last full day of life.

MURDER! POLICE! HELP!

In the maze of confusion that would occur over the next several hours there would be one irrefutable fact: Miss May L. Fosburgh lay dead with a bullet wound to her chest.

May was described as "a woman without an enemy. In her home and in her church life she won the affection of all who knew her. She was her brother's companion, her mother's idol, and to the younger members of the family she was ever helpful."

In the early morning hours of August 20, 1900, shots rang out in the Fosburgh house. What actually happened would become the point of conjecture and wild speculation. Newspapers across the country would cover the unfolding story with spectacular headlines.

The elder Robert L. Fosburgh sustained knee injuries, a possible cracked rib and facial injuries. His son Robert S. Fosburgh also suffered facial injuries and a contusion on his neck. They both claimed to have been involved in a violent struggle with burglars.

THE SEARCH

The number forty-one fire alarm at the corner of North and School Streets sounded, and hundreds of men gathered at the Pittsfield Police Station. They were quickly sent out to block all exits from the city and search for the burglars. The search would continue for over two days and extended all the way to the New York and Vermont state borders. The scope of this massive search in Pittsfield remains unprecedented to this day. One witness arrived on the scene "expecting to see the center of the city in flames." Instead, men talked animatedly about murder while horses were hitched and firearms were distributed. All the roads leading out of town would be heavily guarded.

All able-bodied men were called to join the search:

> Volunteers Wanted:
> *To join to-night in the search for murderers of Miss Fosburg* [sic]. *Chief of Police Nicholson believes the men are still in the city which is surrounded. He desires volunteers to increase this guard and to make a thorough search in Pittsfield. Volunteers should call at Police Station for instructions and arms. Let there be a general response to this call for volunteers.*

So many men arrived that the supply of available guns and horses ran out. Deputy Sheriff William L. Loyd and Deputy Sheriff George H. Frey led a large group equipped with shotguns supplied by Allen Bagg, an employee of the Peirson Hardware Company. A number of R.L. Fosburgh and Son

VOLUNTEERS WANTED!

To join to-night in the search for murderers of Miss Fosburg.

Chief of Police Nicholson believes the men are still in the city which is surrounded.

He desires volunteers to increase this guard and to make a thorough search in Pittsfield.

Volunteers should call at Police Station for instructions and arms.

Let there be a general response to this call for volunteers.

From the Berkshire Evening Eagle.

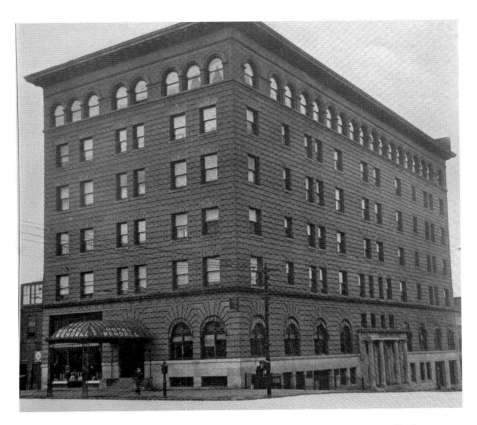

The Wendell Hotel in Pittsfield, Massachusetts. *From* Pittsfield City Directory, *Eagle Publishing 1900.*

Construction Company employees were sent out to aid in the search. One employee found a sock, which he gave to James Fosburgh, who later turned it over to police. Neighboring police departments were also notified. All barns and buildings were thoroughly searched and the city borders secured. Every passerby was questioned. Over the course of the next few days, some fifty hobos and vagrants were rounded up. Other surrounding communities also rounded up suspects, no matter how dubious they may have seemed as potential murder suspects. All were eventually cleared. Newspapers nationwide proclaimed that the city was "thoroughly scoured by police and hundreds of townsmen—no stone was unturned." Despite untiring efforts to locate the perpetrators and bring them to justice, they "disappeared as if the earth opened and swallowed them." The greatest manhunt in the history of Berkshire County would yield no tangible results.

THE WENDELL, NEW FIRE PROOF HOTEL.

Cor. South and West Streets, Pittsfield, Mass.

This new and elegantly furnished hotel opened on Oct. 1st, 1898, and is equipped with all modern improvements, including steam heat, electric lights, elevator, sample rooms, etc.

CONDUCTED ON BOTH AMERICAN AND EUROPEAN PLAN.

RATES. { European Plan, $1.00 per day and upwards.
{ American " 3.00 " " " "

PLUMB & CLARK, Proprietors.

An early advertisement for the Wendell Hotel, a new, modern and "fireproof" hotel. *Berkshire Athenaeum Local History Department Photo Collection.*

Proclaimed in the press as "the crime of the century," newsmen from across the country would soon find their way to Western Massachusetts. The case was a sensation nationwide, thanks to its mix of wealth, social prominence and mystery. Many newsmen took up residence at Pittsfield's Wendell Hotel, built two years prior at a total cost of $250,000. Built in French Renaissance style, the structure was faced with pressed yellow brick and gray limestone. The press would frequent the Tap Room there, known for its "men's club" atmosphere.

Advertisements of the era claimed the Wendell Hotel was fireproof and elegantly furnished with steam heat, electric lights and an elevator. European plans started at one dollar a day, and American plans started at three dollars. Prior to the murder, the Wendell was suffering from severe monetary difficulties. It can be said that May Fosburgh's death saved the hotel from financial ruin. The Wendell Hotel would close for good in 1965 and was torn down shortly thereafter that same year.

For several days after the tragedy, the *Berkshire Evening Eagle* ran the following reward notice:

> *$1500 Reward!*
> *A reward of $500 will be paid for the capture of each of the parties who feloniously entered the residence of Mr. Robert L. Fosburg* [sic] *on the*

$1500 REWARD!

A reward of $500 will be paid for the capture of each of the parties who feloniously entered the residence of Mr. Robert L. Fosburg on the morning of Monday, August 20, 1900.

The persons implicated left behind a patent leather, cloth top shoe, manufactured by Hanan & Son, size 8½, with crescent heel plate, and also a light fawn brown derby hat with dark brown band and binding.

H. S. RUSSELL, Mayor.

Pittsfield, Mass., Aug. 20, 1900

From the Berkshire Evening Eagle.

morning of Monday, August 20, 1900. The persons implicated left behind a patent leather, cloth top shoe, manufactured by Hanan & Son, size 8½, with crescent heel plate, and also a light fawn brown derby hat with dark brown band and binding.

H.S. Russell, Mayor

W. Murray Crane, the governor of Massachusetts, took a special interest in the murder case. Besides visiting the crime scene, he kept in close contact with Pittsfield police chief John Nicholson. Governor Crane resided in Dalton and owned the Crane and Company paper mills, a company that continues to make all of the paper for United States currency to this day.

THE FUNERAL

The *Berkshire Evening Eagle* posted the following funeral notice in its August 22, 1900 edition:

The funeral of Miss May L. Fosburgh, who was murdered by an unknown burglar early Monday morning was held from the home of her parents, Mr. and Mrs. Robert L. Fosburgh at 11:00 this morning. Rev. S. V. V. Holmes, pastor of the Westminster Presbyterian Church of Buffalo, New York, assisted by Rev. Raymond Calkins, pastor of Pilgrim Memorial Church in this city, officiated. The body of the deceased was placed in the receiving vault temporarily, from which it will later be taken to Buffalo for internment.

May Fosburgh's body was placed in a steel casket with silver handles and richly lined with black fabric. There were numerous flower displays, and the casket was completely covered in flowers, mostly roses. Flower petals were on the floor surrounding the casket as well.

Pallbearers were David A. Powers, Herbert Rockwell, George A. Mole, Clifford Buckingham, Samuel G. Colt and Dr. Frank A. Kendall. All were from the Berkshires with the exception of Dr. Kendall, who was from Buffalo, New York.

Music played softly as Reverend Calkins read the Twenty-third Psalm:

The Lord is my Shepherd; I shall not want.
He maketh me to lie down in green pastures;

He leadeth me beside the still waters.
He restoreth my soul;
He leadeth me in the paths of righteousness for His names sake.
Yea, though I walk through the valley of the shadow of death,
I will fear no evil: for Thou art with me;
Thy rod and Thy staff they comfort me.
Thou preparest a table before me in the presence of mine enemies:
Thou anointest my head with oil;
my cup runneth over.
Surely goodness and mercy shall follow me all the days of my life;
and I will dwell in the house of the Lord forever.

Reverend Holmes went on to deliver the eulogy:

My dear friends: We have listened in the tender and solemn service to the rushing music of this psalm, to the comforting words of assurance, and now is there any word left to be said before we lay to rest the remains of the dear one. We feel that it is generally best to close services like this with the words of Holy Writ, but these circumstances are so different; they are so tragic that the heart of this community has been stirred. I feel, therefore, that it is fitting that one who was taken from this life so swiftly and so silently should be eulogized by one who understood this dear one better than you who knew her for so short a time. With the charm of sweet young womanhood she had the distinctiveness of presence and person—a developed mind and a heart that overflowed with love and tenderness. God had gifted her with a voice which brought keen delight not only to her home, but to the social sphere in which she moved. In an unusual degree she was gifted in all qualities we admire and love. As her pastor for many years there were two things which I noticed in her above the rest. First a Christian faith, simple, strong, genuine, which transfigured her life and rendered it beautiful. She was nurtured in a Christian home and her faith expanded like a growing flower. It was simple reverent and child-like, and "of such is the kingdom of Heaven." Then, too, she showed the greatest devotion to duty in home and out of it, and the giving up of her talents, not only in that home, but in her social life, was always self-sacrificing; she was happy when doing things to make others happy and one could always find her giving herself in devoted service. Great as was her gift of voice, greater still was the way in which used it. No matter whether it was in the church or in Sunday school she was ready at all times to devote of her gift to please and emulate others.

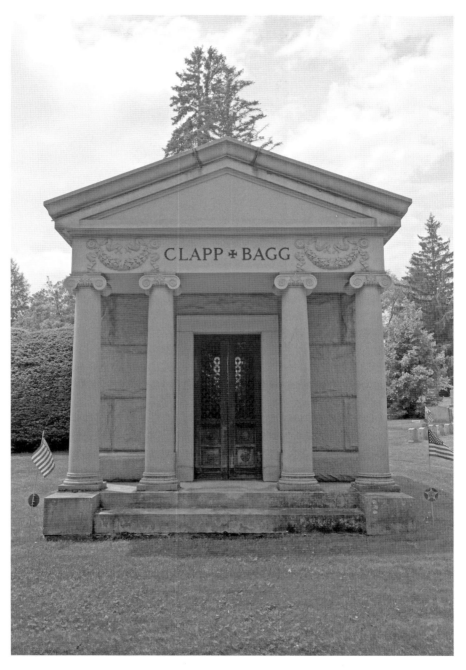

The Clapp Mausoleum at Pittsfield Cemetery, which temporarily held the body of May L. Fosburgh. *Photograph by Frank J. Leskovitz.*

Now that she is gone the city is poor, but who dare speak of poverty in this household. While we are poorer she is richer, and we should remember that her life is going on and will go on in the presence of her Maker, whom she adored and worshipped. And as she is gone it is fitting that we should walk to her grave through a pathway choked with flowers. Let us remember that we are dismissing her out of the shadows in which we stand into the sunlight where she sees her Savior's face.

At this point in the ceremony, friends and family viewed the remains of May L. Fosburgh before her body was transported by carriage to be temporarily held in the Clapp Family Mausoleum at Pittsfield Cemetery on Wahconah Street. The Clapp family ran several local woolen mills. They were incorporators of the Berkshire Athenaeum, Pittsfield's public library, and the generous donors of the Clapp Memorial Chapel and the impressive stone archway with its massive bronze gates that graces the entrance to Pittsfield Cemetery.

THE INVESTIGATION

Pittsfield police chief John Nicholson was appointed to lead the city's police department in November 1886. It was written that during his tenure and under his capable leadership, the Pittsfield Police Department "exhibited commendable efficiency and discipline." Nicholson would personally lead the investigation into the death of May Fosburgh.

Several facts became apparent during the course of the investigation:

- May Fosburgh was shot around 1:00 a.m. on the morning of August 20, 1900. The exact time of death was never precisely pinpointed by the medical examiner.
- An alarm sounded at 1:30 a.m., and police were first notified at 1:48 a.m.
- Responding police officers were not immediately admitted into the residence.
- There were several signs of a struggle within the home.
- The first outsider to view the body was Dr. Walter W. Schofield of Dalton, Massachusetts. He reached the house around 2:30 a.m.
- May Fosburgh was shot in the chest and lay just inside the doorway to her bedroom.
- Powder marks on her nightgown indicated that she was shot from a distance of less than twelve inches away.
- A second shot was fired in the house either before or after the fatal shot was fired.

Pittsfield police chief John Nicholson.
From "Prominent Men of Pittsfield," Berkshire
Sunday Record, *1894.*

- The second shot was fired from the same gun as the fatal shot, and the bullet was found in a comb case on the bureau in the unoccupied kitchen-bedroom.
- A screen window in the kitchen-bedroom was pushed outward and damaged. Upon testing, it could only be opened approximately eleven inches.
- Footprints were observed in the soft earth below the balcony with toes pointing toward the house.
- A derby hat with a missing band was found in the residence.
- A cloth-top patent leather size 8½ shoe was found on the back stairway.
- Burnt Diamond brand matches were collected from the hallway. The family claimed they never used that particular brand of match in the residence.
- Outside on a fence was found a pair of trousers said to belong to Robert S. Fosburgh. Socks were also found nearby.
- Also found outside the residence was a pillowcase alleged to have been used as a mask. The items of clothing and the pillowcase came from within the Fosburgh residence.
- The murder weapon was identified as belonging to Robert S. Fosburgh. It was said to have been stored in a drawer in the bureau located in the kitchen-bedroom. (The physical whereabouts of this firearm were apparently never clearly debated before, during or after the trial. Whatever happened to it remains murky today.)
- In plain sight on top of the kitchen-bedroom bureau was assorted jewelry, which was not disturbed. Among these items were a diamond breast pin and a gold watch belonging to Amy Fosburgh. (The watch was a wedding gift from Robert S. Fosburgh.)
- One of the outside balcony posts exhibited a muddy handprint with distinct finger marks.
- The night of the incident was very dark. The almanac reported that there was no moon.

- The family claimed moonlight illuminated the alleged burglars.
- While picking up his sister Esther Fosburgh at the train depot, the defendant, Robert S. Fosburgh, was overheard telling her that he and their father "have had a scrap."

Chief Nicholson's investigation led him to believe that the burglary story at the Fosburgh home was fiction created by the family and unsubstantiated by facts. His belief was that Robert S. Fosburgh and his father had violently quarreled and May L. Fosburgh was killed while trying to make peace between the men. The violent fight between father and son was suspected to have been precipitated by Robert S. Fosburgh fighting with his wife, Amy Jane Sloan Fosburgh. Nicholson believed that the Fosburghs concocted the burglary story in an attempt to avoid scandal. He also concluded that the harmonious exterior the family portrayed was an illusion. Based on his inquiries, Chief Nicholson obtained evidence that both Fosburgh men possessed stormy tempers and would often disagree with one another.

Gathered evidence and testimony were presented at a closed inquest and submitted to the district attorney for review. Family members were also interviewed at this inquest. Judge Joseph Tucker, justice of the District Court of Central Berkshire, presided over the inquiry. The judge insisted that "the greatest secrecy should be maintained as to the doings of the body." It was determined that there was sufficient evidence to establish probable cause

POLICE MAKE ARREST IN FOSBURGH MURDER CASE

R. S. FOSBURGH HAS BEEN TAKEN INTO CUSTODY.

PRISONER HAS BEEN UNABLE TO SECURE BAIL.

Review of a Crime Which Has Attracted Attention Throughout the Country.

News coverage in the *Berkshire Evening Eagle*, dated January 26, 1901. *From the* Berkshire Evening Eagle.

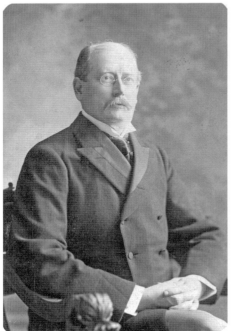

Above: The Pittsfield Police Department. *Photograph by Frank J. Leskovitz.*

Left: Robert L. Fosburgh. *Photograph from the personal collection of Beatrice Lynn Wilde.*

that the defendant, Robert S. Fosburgh, had committed the crime. The grand jury reached its conclusion on January 17, 1901. This action resulted in an indictment being brought against Robert S. Fosburgh. The charge would be manslaughter.

A bench warrant was issued by Judge John A. Aiken, chief justice of the Berkshire Superior Court. Robert S. "Bert" Fosburgh was served the warrant and arrested on Saturday, January 26, 1901, at the Stanley Electric Works by Pittsfield police officers Daniel P. Flynn and James F. Dean and charged in the death of his sister May L. Fosburgh. He was working at the time in the office with Frederick W. Lund, to whom he stated, "This will kill Father."

Fosburgh was brought to the Pittsfield Police Station and held on $20,000 bail. It was hoped he would be released that evening, but the family met with difficulty securing the funds on such short notice, despite the bail amount being reduced to $12,000.

After his son's arrest, Robert L. Fosburgh stated:

> *I was dumbfounded to hear the police suspected my son. I cannot tell you my surprise at his indictment and arrest. I will spend the last cent I have to make him free and I know it will all come out right in the end. It is all foolishness to claim that we were quarreling there. My son is a gentleman, and I have always considered myself one. We never had any friction, either here or in Buffalo. That boy is the pride of my life. If anything happens to him I shall feel like just going out and dying myself. He is as gentle as a lamb. As God is my judge, it has been years since Robert and I have so much as exchanged an unpleasant word. He has been a dutiful son. He is my business partner. The firm is and has been prosperous, and there could be no reason for a quarrel between us. I have arranged to bail Robert out Monday morning. The Stanley Company will furnish a cash deposit. He will also be discharged as soon as he comes up before twelve men.*

Fosburgh also claimed repeatedly that his son's arrest was the result of a jealous person who was angered by the family's success.

Robert S. Fosburgh did not spend the entire time of his arrest in a prison cell. Under police supervision, he was allowed by Chief Nicholson to spend some of the time at the Wendell Hotel while his bail was in progress.

A group of friends from Buffalo, New York, where Fosburgh lived before coming to Pittsfield, wrote: "Robert S. Fosburgh, who is accused of killing his sister, had an excellent reputation in this city. He was in good society while a resident of Buffalo. His habits were as good as most young men of

FOSBURGH RELEASED ON BAIL.

LEFT THE STATION HOUSE AT 11.10 O'CLOCK THIS MORNING.

His Bondsmen are James M. Burns and Arthur A. Mills.

They are Secured Through Check for $12,000 Drawn by the Stanley Electric Manufacturing Company.

News coverage in the *Berkshire Evening Eagle*, dated January 28, 1901. *From the* Berkshire Evening Eagle.

his social position. The news of his arrest came as a great surprise to his many friends here. There seems to be a general opinion that he was in no way connected with the killing of his sister."

On the following Monday, $12,000 in bail money finally secured the release of Robert S. Fosburgh. The funds were presented by bondsmen James M. Burns and Arthur A. Mills and secured through a check issued by the Stanley Electric Manufacturing Company. Upon release, he rejoined his family at the Wendell Hotel, within which they had been residing since shortly after the funeral.

The following morning, Robert S. Fosburgh indicated that he intended to resume his work duties immediately by stating: "I must go out to the works, I have a gang of men there I haven't seen in two or three days." When asked about the many stories and various theories about the tragedy in circulation, Fosburgh responded, "There is only one story. That was given to the reporters on the morning of the burglary." While awaiting trial, Robert

S. Fosburgh continued working on R.L. Fosburgh and Son Construction Company contracts in Pittsfield, as well as additional projects in Westfield and Maynard, Massachusetts.

Robert L. Fosburgh released the following statement regarding his son on January 28, 1901:

> It is because of delays demanded by the laws of Massachusetts that Robert S. Fosburgh will have no opportunity to establish his innocence of the murder of his sister before next July. In the meantime his parents, who assisted him in driving from their home the burglars who shot to death their daughter, ask in his behalf for suspension of judgment. Some person not known by them, inspired by what must be malice which is beyond understanding, has plotted the indictment of their son. No attempt was made to call before the grand jury members of the Fosburgh family, nor was the testimony of neighbors who heard the shots fired by the burglars and who were in the house before Miss Fosburgh breathed her last, called for at the inquest. An attempt has been made to magnify to importance the inability of the police to persuade one witness to come from another state and give testimony at the inquest. So many falsehoods have been circulated in relation to this case that this method is taken of asking for justice for an innocent man who cannot now in any other manner defend himself.

Beatrice Fosburgh also gave a statement describing the events the night her sister was shot:

> I can never forget the things that happened the night May was shot. We had all had such a happy evening. Bertha Sheldon was there, and we had music and everything was nice. I slept with May in a room across the hall from the room occupied by Mamma and Papa. Bertha's room opened from ours. I had been asleep I don't know how long when I was awakened by Papa, who called out loud. Then I heard Mamma scream, and May and I both sprang from bed and started for the hall. May was ahead of me and I stopped to turn on the electric light. My excitement made me slow, but I did not lose many seconds. As the light came on I saw Papa struggling on the floor with two men, wearing white masks. Mamma was trying to help Papa, and in the door was a third man. Toward him May advanced, and then to my horror, he raised a revolver and seemed to take deliberate aim at my sister. He fired and May stopped. Just then brother Robert rushed past me from his room. He caught May in his arms and let her sink to the

floor; then he jumped to the assistance of Papa. The men ran away, one of them firing again just as he stepped through the window to the porch, from which they jumped to the ground. I was so frightened I could hardly speak, but I tried to help May. Papa ran to the window, which he threw open, and began calling for help. The neighbors answered, and very soon we had plenty of assistance. Mr. Plumb, from across the street, was the first to arrive. Then came Henry Shepardson and then Miss Estelle Chapin, Fred Lund, Papa's bookkeeper, also came in, and then the police began to arrive. Isn't it awful that my brother should be charged with this awful crime? I am sorry for him, but I am more sorry for Amy, his wife, and poor Papa and Mamma, who have never gotten over the shock caused by May's death. But I know my brother will show that he is right, and then the persons who have made him so much trouble will be sorry.

The reporters were relentless in their pursuit to obtain information from Pittsfield police chief Nicholson. He explained to them: "I never give out the evidence in a case which I investigate. I do not do it in the simplest case of drunkenness." Despite their nearly constant inquiries, the press by all accounts was treated courteously by Nicholson.

In an interview, Berkshire County district attorney Charles L. Gardner stated that he supported the findings of the investigation led by Pittsfield police chief Nicholson and that he believed that Nicholson held no ill will toward the Fosburgh family. The district attorney was firm in his belief that the shooting of May Fosburgh was not done by burglars. Besides rejecting the burglary theory, Gardner claimed that the Fosburgh family had not been truthful regarding the facts that tragic evening. He went on to say that there were discrepancies in the testimony of individuals at the inquest, which had a great impact on the grand jury. Gardner stated, "There were circumstances and statements which, taken together, convinced the grand jury that the girl came to her death from a pistol held in the hand of a member of the family and that she was not shot by a burglar." In speaking about the shoe found in the residence, Gardner said, "You will readily understand that I will not be justified in making public the evidence gathered by the state, but has it occurred to you that possibly that shoe, which was of patent leather, button and cloth top, would hardly be worn by a tramp burglar?" Still, District Attorney Gardner said he had great sympathy for the entire Fosburgh family and for their suffering. In one article appearing in the *New York Herald*, Gardner was quoted as saying, "Even though this boy is guilty he has suffered enough in the loss of a beloved sister, and it would be cruel and inhuman, even in case of conviction, for him to serve

a day in prison or pay one dollar as a fine." He later claimed to have been misrepresented in the interview.

The local *Berkshire Evening Eagle* was not at all impressed with its big-city competition:

> *The attitude assumed by some of the out-of-town newspapers in this trying time is most deplorable. Within the past few days, newspapers in New*

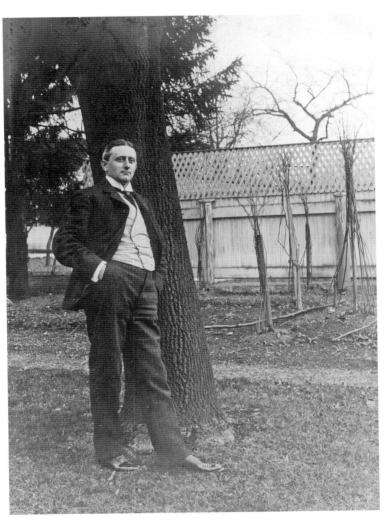

Robert Stuart Fosburgh, circa 1906. *Photograph from the personal collection of Beatrice Lynn Wilde.*

York, Buffalo, Boston and other places have sent representatives to the field. They came up with a view, we presume, of showing the country boys how things are done in the large cities. This charitable interest in the welfare of the Pittsfield newspaper fraternity is as beautiful as it is charitable; but if the methods adopted today by these out-of-town reporters is a specimen of the metropolitan style of doing business, they can do no better than to relinquish the ground to men who have a sense of proportion, quietly pack their grips, and start homeward.

The *Eagle* would continue in its criticism of its metropolitan competitors' "assortment of misstatements regarding the true condition of affairs." It was said that most Western Massachusetts newspapers "represented in Pittsfield by men of sense and judgment, are admirably performing their duty by the public and the court."

Aside from the unrelenting press coverage, Robert S. Fosburgh received letters from all over the United States from "cranks, clairvoyants, romancers, and sensational advertisers galore." A number of the letters came from young women seeking autographs or locks of hair and even a few marriage proposals. They apparently didn't realize he was already married to Amy Sloan Fosburgh.

Seneca Newberry Taylor, a wealthy lawyer from St. Louis, Missouri, and longtime close personal friend of Robert L. Fosburgh, arrived in Pittsfield to aid in the defense of Robert S. Fosburgh. Attorney Taylor was said to be one of the hardest working members of the St. Louis bar. With the press on hand, Taylor had much to say upon stepping off the train at the station in Pittsfield:

Robert Stuart Fosburgh is innocent. And it would be a shame, considering the peculiar phases of this case, to wait six months before giving him an opportunity to prove his innocence. I propose to move without delay for an extra term of court so that this young man may have a speedy trial. An extra term would mean considerable expense, which the taxpayers may not care to stand. I shall offer a bond guaranteeing to pay all the costs of the trial myself, every cent of it. I don't know if there is a precedent for this, but, if not, I will make a precedent. I don't know what can be done but I will immediately consult with Mr. Hibbard [defense attorney], *and we will leave no stone unturned to give Robert Fosburgh an early trial. I mean exactly what I say when I offer to bond myself to pay the costs of an extra term of court. If there is any doubt to my ability the cash will be placed*

on deposit here. Those representing the state have said or broadly intimated that the indictment was returned because of discrepancies in the stories told by members of the Fosburgh family. That is sheer nonsense. No indictment could be so founded. If it has been, it will not stand a test of fifteen minutes in court. I am inclined to believe that perjury has been committed in the grand jury room and that an attempt will be made to build up a murder theory about that old shoe that was left behind by the burglars. Well, that will be attended to in the proper time. Discrepancies in the testimony given by members of this family there has been, I have no doubt. It would have aroused suspicion had there not been. Robert Stuart Fosburgh was struck on the back of the head with a sand bag and stunned. His mother was beaten over the head and shoulders until she was all but unconscious. Mr. Fosburgh was struck across the face by a sand bag and so injured that he did not recover from the blow for weeks. He was knocked down and trampled upon so that he was covered with blows and had two ribs broken. Can it be wondered at that three persons dazed as these must have been were unable to tell stories that correspond in every detail? The day before this murder Mrs. Fosburgh returned to her family from a visit in St. Louis. That Sunday night after music, mostly sacred songs, the family retired. Mrs. Fosburgh, before taking a bath, went into the bedroom occupied by her daughters May and Beatrice. She had an arm around the neck of each. They joked for a moment, and then son Robert, in the next room, called: "Mother, it isn't fair for you to give all your kisses to the girls. Come and kiss me." To this, Mrs. Fosburgh good naturedly responded, "You come here and kiss us." "No," replied her son, "my wife won't let me." So Mrs. Fosburgh went into the next room to give her son and his wife a goodnight kiss. While she was there the daughter as a joke on her mother slipped to the bathroom ahead of her, at which there was a general laugh. The family did not go to sleep until nearly midnight. I tell you these little details to show the spirit of that family and demonstrate that it would have been impossible for its members to have engaged two hours later in a life and death struggle among themselves. They gave testimony at the inquest, and they agreed that there were burglars in the house that night and that one of them shot and killed the daughter May. I will say that I have never known a parallel of the proceedings that have resulted in the indictment of Robert Stuart Fosburgh. In the first place I can conceive of no law that holds an accused in ignorance of the identity of the witnesses who accuse him. That is what is being attempted here, and it is monstrous. All evidence in this case points to the murder of May Fosburgh by burglars. But all that evidence is rejected by the chief of police.

Much mystery and several theories swirled around family guest Miss Bertha Sheldon and exactly what she had or had not seen. Her father, Frank P. Sheldon, admitted that he should have allowed her to testify at the inquest. He had hoped to protect her and spare her from the notoriety surrounding the case, but quite the opposite occurred instead. She became the subject of much speculation. Miss Sheldon was said to be suffering from nervous exhaustion, and her family had the desire to banish thoughts of the tragedy from the young woman's mind. It was explained that Miss Sheldon (who had hearing difficulties) awoke due to the sound of gunshots and opened the adjoining bedroom door to view May Fosburgh on the floor with her family surrounding her. She did not hear any struggles preceding the shots, and she never saw any intruders in the house. She left for her family home in Providence, Rhode Island, a few hours after the incident. Even though the tragedy had greatly upset her, Miss Sheldon was said to be prepared to return to Pittsfield for the trial if she was called to testify. She was anxious to clear up any misconceptions in the minds of the public or the press. Prior to the start of the trial, Mrs. Robert L. Fosburgh traveled to Providence, Rhode Island, and met privately with the Sheldon family. In an interview, Robert L. Fosburgh stated that Miss Sheldon was nearly deaf and that they had to shout at her in order to communicate. He theorized that if she had not been awakened by the firing of gunshots, she would have slept through the night.

Judge William B. Stevens of Stoneham, Massachusetts, was assigned to preside over the trial, which would be held in Berkshire County Superior Court. Judge William Burnham Stevens was born on March 23, 1843, in Stoneham, Massachusetts, where he resided throughout his lifetime. He attended Phillips Andover Academy before enrolling in Dartmouth University. His education was interrupted at the end of his first year when he enlisted in Company C of the Fiftieth Regiment, Massachusetts Volunteers, and served nine months at the front. He thereafter resumed his education at Dartmouth and graduated in 1865 with honors. In 1867, he was admitted to the Suffolk County Bar. An appointment would come in 1898 as an associate justice of the Superior Court of Massachusetts: "Judge Stevens gained an enviable reputation at the bar, and displayed those rare judicial qualities which won for him an appointment to the bench. He is an able trial lawyer, expert examiner of witnesses, and a wise counselor and as a citizen is spirited and progressive."

Hampshire County district attorney John Chester Hammond would prosecute the case with the assistance of local attorney John Crawford Crosby. (Berkshire district attorney Charles L. Gardner was said to be in poor health at the time of the trial.)

John C. Hammond was born in 1842 in Amherst, Massachusetts. He practiced law in Northampton, Massachusetts, and would later become a judge in the Hampshire County Superior Court. In 1895, he employed Amherst College graduate and future president Calvin Coolidge in his practice. Coolidge described Hammond in his 1929 autobiography: "He was a lawyer of great learning and wide business experience, with a remarkable ability in the preparation of pleadings and an insight that soon brought him to the critical point of a case. He was massive and strong rather than elegant, and placed great stress on accuracy. He presented a cause in court with ability and skill." Hammond would die in Northampton in 1926.

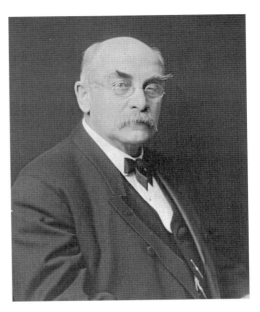

Attorney John C. Hammond. *From* Memoirs of the Judiciary and Bar of New England, *Century Memorial Publishing, 1901.*

Attorney John C. Crosby was born in Sheffield in 1859. He attended Eastman Business College and the Boston University School of Law. In 1882, he was admitted to the bar in Pittsfield, Massachusetts. Crosby served in the Massachusetts House of Representatives and Massachusetts State Senate and from 1891 to 1893 was elected to the United States House of Representatives. He served a term as Pittsfield's third mayor

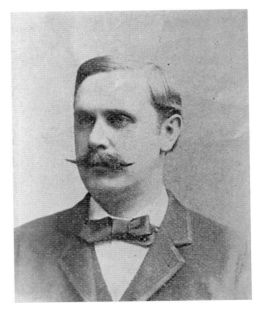

Attorney John C. Crosby. *From "Prominent Men of Pittsfield,"* Berkshire Sunday Record, *1894.*

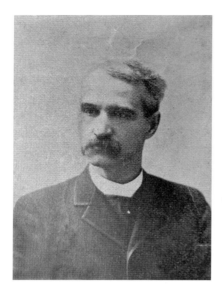

Attorney Charles E. Hibbard. *From "Prominent Men of Pittsfield,"* Berkshire Sunday Record, *1894.*

during the years 1894–1895. He was justice of the Massachusetts Superior Court from 1905 to 1913. From 1913 to 1937, Crosby served as a justice in the Massachusetts Supreme Judicial Court. Crosby died in 1943. A middle school in Pittsfield still carries his name today.

Robert S. Fosburgh would be represented by Attorneys Herbert C. Joyner and Charles E. Hibbard.

Herbert C. Joyner was born in New Hartford, New York, in 1838. Joyner served in Company E of the Forty-ninth Regiment, Massachusetts Volunteer Infantry. He practiced law in Great Barrington, Massachusetts. Joyner was elected to the Massachusetts House of Representatives and was also a member of the Massachusetts State Senate, serving a total of six years. He was included in a listing of Massachusetts attorneys who were "specially recommended as reliable men." Joyner represented the Southern Berkshire District. He was well known "throughout the county as one of the most persistent lawyers at the bar."

Charles E. Hibbard was born in 1844 in Farmington Falls, Maine. He attended Phillips Andover Academy and was a graduate of Amherst College. Hibbard served as district attorney for the Western District of Massachusetts from 1887 to 1893. A respected lawyer, Hibbard was said to be "one of the most persevering and shrewd trial lawyers in Berkshire County." He served as the first mayor of Pittsfield, Massachusetts, in 1891 and was a delegate to the Massachusetts Constitutional Convention from 1917 to 1919. Hibbard died in the city in 1922.

Robert S. Fosburgh appeared in Berkshire Superior Court in Pittsfield on Wednesday, July 17, 1901, with Attorney Herbert C. Joyner by his side and pleaded not guilty to an indictment for manslaughter. On this day, Fosburgh was described as being five feet, eight inches tall and slim, with black hair and dark piercing eyes and a clean-shaven face. It was an act of courtesy toward the Fosburghs to permit the defendant to enter the courtroom unannounced and to plead to the indictment mostly in private.

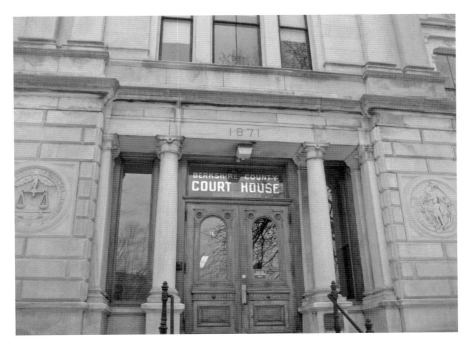

The Berkshire County Superior Court. *Photograph by Frank J. Leskovitz.*

The indictment was read by clerk of courts Frank H. Cande:

> *Robert Stuart Fosburgh, listen to the indictment the grand jury has found against you.*
>
> *Commonwealth of Massachusetts. Berkshire, ss.*
>
> *At the superior court began and holden at Pittsfield within and for the county of Berkshire on the second Monday of January, in the year of our Lord one thousand nine hundred and one. The jurors for said commonwealth on their oath present that Robert Stuart Fosburgh of Pittsfield in the county of Berkshire aforesaid, on the twentieth day of August in the year of our Lord one thousand nine hundred, at Pittsfield aforesaid in the county of Berkshire, aforesaid did assault, shoot and beat May L. Fosburgh and by such assault, shooting and beating did kill the said May L. Fosburgh.*
>
> *A true bill:*
>
> *George W. Haff, Foreman*
>
> *Charles L. Gardner, DA for the Western District*

"What say you to this indictment? Are you guilty or not guilty?" In a clear, strong voice Robert S. Fosburgh replied, "Not guilty."

A newspaper article speculated that "this case is unique in many of its features and will rank with the Lizzie Borden case at Fall River, the most famous trial ever held in Massachusetts—perhaps in this country."

TRIAL DAY ONE:
THURSDAY, JULY 18, 1901

Judge Stevens solemnly entered the courtroom and stood with his eyes straight forward and his hands folded as the crier proclaimed, "Hear ye, hear ye." Every available seat in the Berkshire County Superior Court was occupied. The crowded courtroom was described as being "roomy, clean and attractive looking, and as comfortably cool as can be expected in this sweltering and oppressive dog day weather." Some fifty members of the press were said to be in attendance. Many women were among the spectators. With no standing allowed, the judge ordered the courtroom doors locked and called the proceedings to order.

During the course of the trial, special seats were held aside for the Fosburgh family, along with additional seating for friends and supporters of the family. Several individuals of social prominence and influence in Berkshire County would use these seats. W.B. Plunkett of Adams was one such individual. It was openly suggested that seeing a person of such social and political prominence present in direct support of an accused person might influence a juror's belief regarding a defendant's guilt or innocence.

The *Great Barrington Courier* reported:

> *In some respects the trial wears the garb of a social function. The Fosburgh family is usually surrounded by a large circle of friends and, accidentally or otherwise, the more prominent the friend the more in evidence is he or she as to the position within the bar. Dr. Davis, pastor of the First Congregational Church, has been a constant attendant. He is considered a close friend*

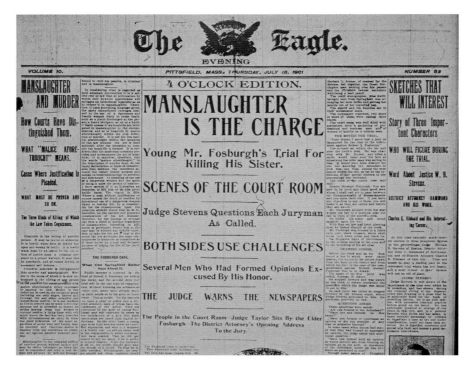

News coverage in the *Berkshire Evening Eagle* dated July 18, 1901. *From the* Berkshire Evening Eagle.

and partisan of the family. Hon. W.B. Plunkett sits with the family one day, Frank W. Hinsdale another day and Seneca N. Taylor, the St. Louis lawyer, who is really a man of fine presence, every day. Before the court opens and before it closes there are greetings, smiles and some caressing. Words that are apparently ones of encouragement are spoken by ladies and others to the defendant, and now and then some woman pats him on the shoulder, as though to say, "Keep a stiff upper lip." And the defendant seems to be keeping up that kind of lip. From the courtroom the family and friends often go as a group, stopping possibly at the fountain next to the Wendell for cooling drinks. At the Wendell, an informal reception in the corridor and parlors, seems to be in constant progress.

The group of potential jurors was questioned as follows by the clerk of courts: "Do you solemnly swear that you will make true answers to such questions as shall be put to you by the court in the matter now in hearing?"

Twelve Berkshire citizens were appointed to the jury on Thursday, July 18, 1901:

Norman H. Sweet—Williamstown, MA—farmer
Egbert Yale—Stockbridge, MA—carpenter
Michael Nevin Jr.—Washington, MA—farmer
Wallace Orton—Williamstown, MA—carpenter
Charles Wolfe—Stockbridge, MA—blacksmith
Joseph Ramsey—Egremont, MA—laborer
John R. Hillard—North Adams, MA—iceman
Charles E. Platt—Great Barrington, MA—merchant
Erwin F. Barnes—West Stockbridge, MA—miller
Edwin L. Boardman—Sheffield, MA—farmer
Nathan B. Baker—Savoy, MA—farmer
Ralston F. Little—Sheffield, MA—farmer

During jury seating, the defense challenged one man, and the state challenged two. Jury selection was completed in approximately thirty minutes. Men who resided in Pittsfield were intentionally excused from serving on the jury. Interestingly, upon questioning, Erwin F. Barnes responded that he had indeed formed an opinion regarding the case. Despite this, he was accepted and appointed foreman of the jury.

After impaneling the jury, Judge Stevens sternly addressed reporters in the courtroom, suggesting contempt of court charges and possible "withdrawal of the case from the jury as a result of any improper criticism or statements as to the evidence in the case."

During his opening statement, District Attorney John Chester Hammond instructed the jurors that they were to consider the charge of manslaughter and not murder. He stated that there were no intruders in the Fosburgh home that night. The burglar story was false. Talk of pillowcase disguises were false. The bullets could not possibly have been fired as the defendant claimed.

Bert's wife had her nightgown shredded down the entire front, and there were other suggestive facts in the case. Furniture in several rooms had been broken and overturned in a most significant manner, casters had been broken on the old gentleman's bed and in the kitchen-bedroom. The screen in one of the windows was also crushed as if by some parties falling against it in a struggle. Were the father and son "scrapping" when the pistol shot was fired? Manslaughter may be a very great crime, according to the

circumstances surrounding it. The jury must not be led away from finding a true verdict by any suggestion as to the importance of this case. It should be satisfied that the court in this state of Massachusetts will properly deal with the matter when the time comes. The duty of the jury is to only determine the question whether Robert Stuart Fosburgh killed his sister.

District Attorney Hammond claimed in his opening statements that the defendant offered a different story daily about what had occurred. Robert Fosburgh said he saw two burglars jump from the balcony and another run down the stairs and escape. They allegedly ran across the field between Woodlawn Avenue and Tyler Street. There was a very heavy dew that morning, but not a particle was disturbed. "Was that story true? Could it have been? Tell a country boy who knows grass and dew such a story and he would say: 'What are you giving me?'" Hammond continued by stating that the family had earlier alleged that May Fosburgh was shot from a distance of six, seven or eight feet. Powder marks left on her nightgown indicate a different story. Hammond stated that May L. Fosburgh was shot with a .32-caliber center-fire revolver owned by the defendant and held less than one foot from her body. Beatrice said she was behind her sister May when she fell. There was no light on at the time of the shooting, though one was turned on by Beatrice shortly thereafter. Hammond stressed that "the night was one of intense profound darkness clear through dawn." Beatrice claimed there was no man between her and her sister and that it was too dark to distinguish the man in the hall. The defendant, Robert S. Fosburgh, claimed he was behind his sister when she fell. The defendant also stated that May's room was so dark he could not see her when the shot was fired, and when she fell in his arms he did not recognize her. The defendant described the intruders he fought with in detail. Hammond suggested that this should have been impossible in the darkness. Robert S. Fosburgh said they were all bareheaded and without disguise. One had on a brown suit of clothes. Later, he and his father both claimed the second burglar appeared at the father's bedroom door wearing a pillowcase mask and carrying a revolver in his left hand and a lantern in his right. There could have been no more ten seconds between these occurrences. The family gave no notice to police for a half hour following the tragedy. James Fosburgh woke after the shooting, ran upstairs, saw his sister, sent Beatrice for ammonia, decided to get a doctor, found keys to the Stanley office, got some clothing on, went to a neighbor's house to inquire about a doctor and then returned to the house before "the family in this awful straight has called murder." All this time passed before

James learned of the burglar theory. At this early stage, no one but Robert L. Fosburgh and the defendant claimed to have any knowledge of the intruders. When any outsiders finally got to see the household, they were dressed, with both Robert L. Fosburgh and the defendant in collars and ties. The district attorney, continuing to challenge the burglary story, stated that the window screen from which the intruders allegedly escaped could only be raised eleven inches. Additionally, the bullet in the comb case on the bureau could not have been fired from a burglar escaping through the window as described. The bullet was fired from above and could only have been fired from within the room. He also questioned why the burglars would leave behind jewelry and make off with stockings, a pillow case and a pair of pants. Hammond also claimed that the burglars couldn't climbed up into the house as the defendant suggested they did. The dirty hand mark appeared on the porch post and in no other place. Evidence at the Fosburgh house indicated occurrences that had absolutely no connection to an alleged burglary. The Commonwealth of Massachusetts claimed that "Robert S. Fosburgh was the only one who did or could have fired that pistol. He fired the fatal shot."

To the surprised courtroom, District Attorney Hammond also asserted that the defendant and his wife had separated after the murder. The mother of the defendant was said to have turned white at the revelation.

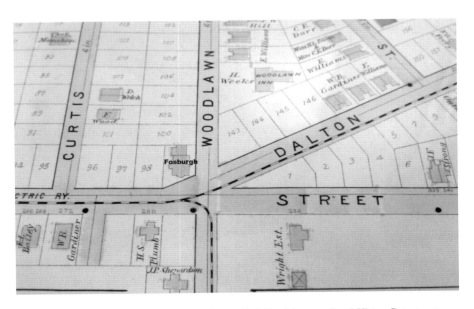

The area surrounding the Fosburgh residence. *Berkshire Athenaeum Local History Department Map Collection.*

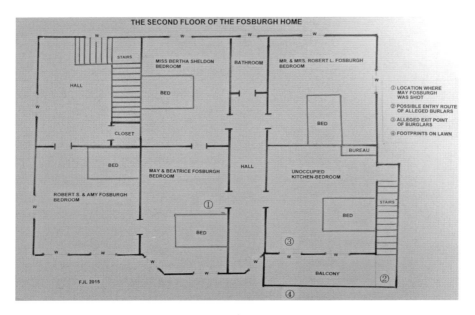

The second floor of the Fosburgh residence. *Author's rendering.*

Hammond finally instructed, "If the girl was killed through the angry carelessness on the part of her brother or during the excitement of a family quarrel, he is guilty."

The jury was then taken to the site of the tragedy so they could become familiar with the scene of the crime. At approximately 11:00 a.m., the jury, along with council and accompanied by Sheriff Deputies Pierce and Quirk, took an electric streetcar to the Fosburgh home to view the premises.

Upon the start of the afternoon session, the first witness was Pittsfield city engineer Arthur A. Fobes. At the request of Pittsfield police chief John Nicholson, Fobes and his staff created exhaustive plans of the Fosburgh house and its surroundings. These plans were prominently displayed on the courthouse wall. They showed the location of doors and windows and furniture in the home, especially around the area of the second-floor murder scene. Also shown in detail were distances to the neighboring streets and houses. Fobes was paid five dollars for his drawings.

The second and final witness of the day was medical examiner Dr. Franklin Kittredge Paddock. Dr. Paddock was a highly respected "larger than life" type of individual in the Berkshires. He was born in 1841 in Hamilton, New York, and from an early age suffered from rheumatism and heart disease. He graduated from Berkshire Medical College in 1864 and was the dean and a professor

there until its closing. He received an honorary master of arts degree from Williams College and was the medical director of the Berkshire Life Insurance Company. Paddock was a former president of the Massachusetts Medical Society and the principal surgeon at the House of Mercy. He had been medical examiner of Berkshire County since 1881.

Dr. Paddock testified that he had been practicing medicine for thirty-seven years and had been medical examiner of Berkshire County for the past twenty years. During his testimony, Dr. Paddock was in obvious poor health and experienced several bouts of faintness. According to the prosecution, his health issues

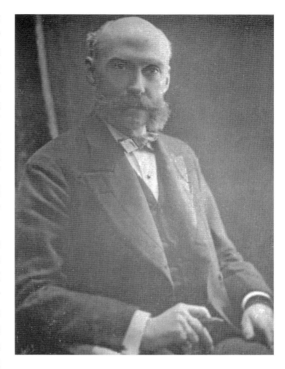

Dr. Franklin Kittredge Paddock. *Photograph from the personal collection of Christine Paddock Foster.*

were the cause of him "forgetting a few things during testimony." Dr. Paddock first viewed May Fosburgh's body on the floor at the entrance to her bedroom, her feet about thirty inches from the doorway leading into the dark little hallway. May Fosburgh's bloody nightgown and a .32-caliber bullet recovered from her body during an autopsy completed by the witness were presented into evidence. Also displayed was a comb box removed from the spare room bureau said to have been struck by a bullet. It was decided at this point to end proceedings for the day and have Dr. Paddock return the next day in hopefully better health to continue his testimony.

A female spectator in the courtroom wrote of Dr. Paddock:

> He looks tired and worn and sick, as he stands there, a remarkable figure even if now a pathetic one—his very name a household word in the homes of Berkshire. A kind face and a strong one. A man whose very presence inspires confidence anywhere, whose personal influence is not bounded by

the sick room. People feel instinctively the same trust in him his patients do, and what that confidence is anyone who has ever seen Dr. Paddock in a troubled home knows. So thoroughly does he live in his profession that we cannot picture the profession without him. Honesty and saving common sense are the qualities we admire Dr. Paddock for no less than the professional skill which has endeared him to so many. The doctor's testimony which is to be of so much importance in this trial is given in his convincing, earnest, honest manner. It is hard work for him to testify. He is a sick man. Friends among the spectators who know his malady tremble, fearing he may fall. A glass of water is placed by him. The court kindly asks if he wished to be excused. "No," he bravely says. "I'll go on. It's nothing. I have this all the time."

Trial Day Two:
Friday, July 19, 1901

Against objections from the defense, Judge Stevens announced that he would allow testimony regarding tests made by experts to demonstrate the distance at which gunpowder would be deposited on cloth. He further stipulated that the revolver and type of cartridge must be identical in nature to the revolver and cartridge said to have inflicted the fatal wound to May Fosburgh. These tests were conducted by Dr. Frank Paddock, medical examiner of Berkshire County; Dr. Frank Draper, medical examiner of Suffolk County; and General Jephanus H. Whitney of the Massachusetts State Police. The tests were conducted on pieces of cloth taken from the nightgown May Fosburgh was wearing at the time of her death, as well as similar fabrics.

Dr. Franklin Kittredge Paddock returned to the stand and related his conversations with Beatrice and James Fosburgh. He testified that both individuals stated to him that they had seen no burglars in the Fosburgh home. Beatrice further stated to Dr. Paddock that she was directly behind her sister May when she fell to the floor. She said she saw no one except members of her household. He testified about how the family members were dressed and also offered that it was quite dark in and around the house. Dr. Paddock went on to describe the injuries alleged to have been inflicted by burglars on the Fosburghs, both father and son. Dr. Paddock described returning to the Fosburgh residence to conduct an autopsy on May Fosburgh. He was assisted by Dr. Henry Colt, assistant medical examiner. The defendant, Robert S. Fosburgh, rose from the breakfast table and vehemently objected. His father intervened and stated, "Don't interfere. Let the law take its course."

News coverage in the *Berkshire Evening Eagle*, dated July 19, 1901. *From the* Berkshire Evening Eagle.

Dr. Paddock determined that May L. Fosburgh died as a consequence of a revolver shot, resulting in a mortal wound to her chest, heart and left lung. The autopsy completed by Dr. Franklin Kittredge Paddock, longtime physician, surgeon and medical examiner of Berkshire County for some twenty years, was offered to the court as evidence. Judge Stevens declared that it was not competent and refused to allow it.

The text of the court-rejected autopsy report follows:

> *In conformity with Section 12 of Chapter 26 of the public statutes, I make herewith a record of the autopsy of the body of May L. Fosburgh, aged 24 years, found lying at her father's residence, Tyler Street, and supposed to have come to death by violence; the said autopsy was made by the authority*

of the district attorney at 8:30 o'clock in the 20th day of August, A.D., 1900, in the presence of Dr. Henry Colt, resident at Pittsfield, and Dr. W.W. Schofield, residing at Dalton, witnesses.

Autopsy made seven hours after death. Body of a healthy, vigorous woman, 24 years of age. Bloody broth filled the nostrils and mouth. Blood flowed freely from the mouth when body was moved. There was a bullet wound in left side of chest midway between left nipple and middle of left clavicle. Dried blood found on skin about wound. No other external evidence of injury. Rigor mortis well marked. Upon opening the thorax the left pleural cavity and pericardium were found filled with fluid blood and blood clots. The bullet wound entered the chest through the second inter-costal space, three and one-half inches above the left nipple extending obliquely backward towards the spine, penetrating the upper lobe of the lung and the left auricle; passed through the seventh rib in its exit from the chest cavity, close to the spinal column. The bullet (32 caliber) was found at the back end of the wound in the muscle of the back, one and one-half inches left of the spine of the eighth dorsal vertebra. The ventricle was found contracted and empty. The right lung was uninjured, and in normal condition. The brain and the organs in the abdominal cavity were in healthy condition.

And I further declare it to be my opinion that the said May L. Fosburgh came to her death by a bullet wound of heart and lung, which bullet was fired from a revolver by an unknown masked burglar.

Dated at Pittsfield in the County of Berkshire, this 20th day of August, A.D., 1900. Frank K. Paddock, Medical Examiner

A local hardware merchant, Frank E. Peirson, took the stand to testify that in June 1900, defendant Robert S. Fosburgh purchased a Harrington and Richardson nickel .32-caliber hammerless center-fire revolver, along with cartridges to fit the weapon. The revolver retailed for approximately six dollars. The manufacturer claimed the hammerless design was "absolutely safe" and that the weapon could not be fired without pulling the trigger, ensuring against accidental discharge. Peirson's employee Allen H. Bagg also testified about the purchase of the firearm by Robert S. Fosburgh.

The Harrington and Richardson Company factory was located on Park Avenue in Worcester, Massachusetts. (Firearms produced by the firm during this period are highly collectible. Large quantities of this particular revolver were produced between 1899 and 1941.)

The Peirson Hardware Company also distributed firearms in the early morning hours after the murder. They would eventually be reimbursed

(XIX)

THERE IS JUST ONE RULE TO FOLLOW IN PUR=
❦❦❦❦❦❦ CHASING HARDWARE.

Buy where they carry
Only Good Goods ! ! !

Peirson Hardware Co.,

(Established 1853.)

"RIGHT IN THE CENTER OF THE CITY."

WHOLESALE AND RETAIL !

Hardware ! Iron and Steel !

Fishing Tackle ! Golf Goods !

Guns ! Rifles ! Revolvers !

Paints ! Oils ! Brushes !

Glass ! Cutlery ! Scales !

Woodwork ! Cordage !

An early advertisement for Peirson Hardware. *From* Pittsfield City Directory, *Eagle Publishing 1900.*

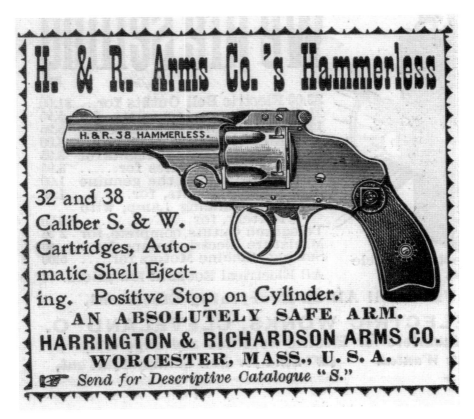

A Harrington and Richardson revolver advertisement, circa 1889. *Author's collection.*

$106.56 for doing so. (Peirson employee Allen H. Bagg would later go on to spend several years as a highly respected mayor in Pittsfield and donate the land that created Clapp Park in the city.)

Pittsfield police chief John Nicholson followed and stated that he had witnessed tests being conducted on a similar Harrington and Richardson revolver. He identified shells used by Dr. Paddock in his testing and cartridges taken from the kitchen-bedroom at the Fosburgh residence.

During the trial, Chief Nicholson sat at a desk with clerk of courts Frank H. Cande. The police chief's wife and daughter were often present at the proceedings. The *Berkshire Evening Eagle* wrote:

> The chief's face is a study, if any man's ever was. Interest in him is alone equaled by the interest manifested in the defendant. Taciturn, reserved, quiet, determined, no look on his face or movement of his countenance indicates

what he is thinking about. But everyone watches the chief, and everybody wonders what the secrets are which he can disclose with reference to this famous Fosburgh case. The chief is in charge of various exhibits, photographs, revolvers, garments of several sorts, the pillow case masks, the shoes, the brown derby hat and the night gown in which May Fosburgh was clad when she met her death. As from time to time, these are required, the chief hands them over.

Evidence was next introduced by William H. Rose of Cambridge, Massachusetts, employed by a Boston firearms company, to show the make of the fatal bullet. A short recess in the proceedings was then called.

After recess, John P. Connor, a Pinkerton detective, was called to describe his attempts to locate the alleged burglars in the case. He was followed by General Jephanus H. Whitney of the Massachusetts State Police. As Whitney testified, court officers brought in the bureau and comb box from the Fosburgh home as evidence. He stated that the bullet that struck the comb box must have been fired from a point as high as a man's head and from the center of the doorway, not from the window as the defendant claimed. Whitney related that when he interviewed Robert S. Fosburgh, the defendant told him he was awakened by his wife, who thought she heard noises in the attic. The second time, he was suddenly awakened by an explosion and ran out and caught his sister May Fosburgh as she fell to the floor. At the same moment, he saw a man in the doorway. They struggled, the man broke away and Fosburgh was hit by a sandbag. One man went out through the window, and a second fled down the stairs. The defendant then fought with a third man. This last individual broke away, reached the window and fired one more shot before fleeing.

Dr. Frank Draper, medical examiner of Suffolk County, testified that the bullet that ended May Fosburgh's life was fired from a distance of no more than eight inches from her breast. (Her family members had previously claimed that she was shot from several feet away.) In vivid demonstration as he testified, Dr. Draper held May Fosburgh's bloodstained nightgown with his finger pointing toward the bullet hole. Dr. Draper testified that he had done this type of work for over twenty years and had prepared similar tests in six other cases. The defense once again objected to this evidence, but it was accepted by the court.

Pittsfield city engineer Arthur A. Fobes was recalled as the last witness of the day. He was asked to describe the sketch of the kitchen-bedroom in the Fosburgh home and the location of the bureau and comb box. He drew lines on the sketch to demonstrate the direction in which the government claimed the bullets were fired.

TRIAL DAY THREE: MONDAY, JULY 22, 1901

In the courtroom on this day, Judge Stevens recognized a special guest, Judge Roger A. Pryer of the New York Court of Appeals. Pryer spent the afternoon seated with Judge Stevens.

The *Berkshire Evening Eagle* reported that thus far in the trial "there is little, if anything, that can be fairly characterized as exciting, even mildly exciting."

Pittsfield city engineer Arthur A. Fobes returned to the stand to complete his testimony regarding the layout of the Fosburgh home and arrangement of the furniture. His testimony was intended to illustrate the path of the bullet fired toward the bureau.

Nelson James Hall was called to the stand. He told of visiting the house at 4:00 a.m. following the shooting and finding a pair of "black half hose with white dots" and a single sock in the grass beside the road. He also observed tracks of bare feet in the road. He was in the company of James Hayes, John Callahan and one other man. James Hayes located a blue sock. All were turned over to Pittsfield police officer George E. Chapman. The men had come to the area after hearing the fire alarm sound and learning of a murder.

James Hayes heard the fire alarm and went first to the fire station and next to the police station. (Both the fire and police stations in Pittsfield were a little more than a mile away from the Fosburgh home.) He testified to finding the socks and seeing barefoot tracks in the road before eventually returning home with Nelson James Hall.

William Dunn and Harold W. Hopkins testified about finding a pair of trousers and a pillowcase on nearby Benedict Road, claimed to have been

News coverage in the *Berkshire Evening Eagle*, dated July 22, 1901. *From the* Berkshire Evening Eagle.

worn as a mask by the burglars. The trousers were hanging from a fence. The time was approximately 5:30 a.m. Dunn was a driver at the fire station and had been out earlier with an armed group of a dozen men searching for the alleged burglars. Attorney John C. Crosby asked to put the pillowcase

on Hopkins to demonstrate the holes cut in it, but Judge Stevens declined the request.

Sheldon S. Wheeler, a photographer, testified to taking photos in and around the Fosburgh residence on September 17, 1900. He identified photos taken of porch posts at the Fosburgh home, including one dirtied with handprints. The defense objected to this particular evidence on the grounds that there was no proof that the posts were in the same condition as on the day of the crime. Judge Stevens ruled that the photographic evidence would be allowed. Wheeler also identified interior photos taken on September 16, 1900. They showed the locations of furniture and the layouts of the various

DR. SCHOFIELD.
(Witness for Prosecution)

Dr. Walter W. Schofield of Dalton, Massachusetts. *From the* Berkshire Evening Eagle.

rooms. It was stated that Pittsfield police chief Nicholson opened some of the doors prior to Wheeler's taking photographs but that no furniture was moved.

The next witness was Dr. Walter W. Schofield of Dalton, Massachusetts, the first outsider to view May Fosburgh's body after the shooting. He described being called to the Fosburgh home at 1:30 a.m. and arriving there at 2:00 a.m. A man at the road holding a lantern stated, "You are too late, Doctor. The girl is dead." It was too dark for him to identify the man. He found two policemen guarding the Fosburgh door (they hadn't yet been allowed access into the house). He entered the house and went upstairs. On the floor of the bedroom he saw May Fosburgh. She was covered with a sheet and had a pillow placed under her head. Dr. Schofield examined the body and confirmed that she was dead. He observed blood flowing from the ears and nostrils. Blood clots were forming in the nostrils. He noticed the night dress she was wearing was covered in blood. There was no light on in the room, but light shone in from a nearby room. The witness testified that he then saw three women in the bedroom whom he was able to later identify. Sitting on the bed was

Mrs. Robert L. Fosburgh and her daughter Beatrice. Standing at the foot of the bed was Amy Fosburgh, wife of the defendant. Dr. Schofield wasn't certain about seeing a fourth woman in the room. There was a man standing in the doorway between the room and the hallway. Schofield believed it to be the defendant, Robert S. Fosburgh. Robert L. Fosburgh appeared behind his son. The family appeared to be completely dressed. Dr. Schofield asked, "What has happened, and who has committed this terrible deed?" Mrs. Robert L. Fosburgh replied, "Burglars have been in the house and killed my poor May."

Dr. Schofield related that Robert L. Fosburgh told him he awoke to find a man standing in front of him with a gun in one hand and a lantern in the other. The revolver was within a foot of his head. Fosburgh said he sprang up and struck the hand holding the gun and grappled with the intruder. Next, the senior Fosburgh stated he was struck in the head and knew nothing for a few moments. When he recovered, he discovered that his son had also been assaulted. Dr. Schofield stated he was told that the revolver carried by the burglar was found under Robert L. Fosburgh's bed, but he never saw it. Robert L. Fosburgh did not describe the burglars or say where they went after the crime. The story of the intruders was related to Schofield to the point of their escape. Dr. Franklin Kittredge Paddock arrived on the scene, and that conversation ceased. The witness turned his attention to Dr. Paddock to assist him. They opened the night dress and examined the wound to May Fosburgh's breast, after which she was placed on her bed. The Fosburgh women were said to be in hysterics, so the doctors sent Frederick Lund and another man to summon a nurse.

Dr. Schofield described the wounds he had found on the heads of each man. The defendant's left eye was blood-red and the area around it swollen and bruised. His neck was also reddened. Robert L. Fosburgh was severely bruised on the cheek, and both ears were injured. His left eye was swollen shut.

Schofield stated that he was told nothing of a pillowcase. He asked the defendant if any valuables had been taken and was told there was nothing taken besides a revolver.

The next witness was Mrs. Mary Nash, who did the laundry for the Fosburgh family. Nash testified that she had done the weekly washing on several occasions before the murder. The Thursday after the murder, she stated that there were three sheets, a large number of towels, a torn night dress, a torn pillowcase, a night shirt and three other pillowcases. The night dress was torn from top to bottom.

Officer George E. Chapman testified that he found several Diamond brand matches in and outside his house that did not belong to Chapman's family. They were said to be similar to matches found in the Fosburgh home. (During this period, Diamond Match Company was America's largest match manufacturer. Diamond is the oldest ongoing match manufacturer in the United States, and its name is synonymous with matches to this day.)

State police detective James McKay was called. He testified that Beatrice stated in his presence that she had seen no one in the Fosburgh home except family members at the time of the shooting. McKay was briefly asked about a ripped night dress belonging to the defendant's wife and also about various pieces of broken and misarranged furniture. He visited the house at 2:00 p.m. on August 21, 1900, with state officers Whitney and Dunham. They were shown around by Frederick Lund. He noted the bloodstain on the floor in May Fosburgh's room, broken bed casters in two rooms and the broken screen, which was down. General Whitney experimented with the screen. Lund brought to his attention another set of footprints, which he could not distinguish. McKay also related that the Thursday after the tragedy, Robert S. Fosburgh indicated that he had some confidential information to give General Whitney but didn't want it revealed to Pittsfield police chief Nicholson.

Defense Attorney Joyner mentioned for the first time in the trial a "Wire Gang" that the Fosburgh family believed to be involved in the shooting. McKay was asked if a list of names taken from a Great Barrington hotel register contained the names Hackett, Patterson, Bly or Quinn. "I am not acquainted with Quinn," McKay replied.

District Attorney Hammond next called James B.A. Fosburgh, twenty-two, a recent graduate of the Sheffield Scientific School at Yale and younger brother of the defendant, Robert S. Fosburgh. James Fosburgh testified without hesitation, in a clear deep voice. He was described as looking slightly nervous when his sister's name was mentioned. The witness testified arriving at the home on July 3, 1900, and staying there until the shooting. The Sunday before the shooting, he attended morning church services at the South Congregational Church with his sister May and Miss Sheldon. James Fosburgh and his family ate together at 1:30 p.m. Esther was away, visiting in Adams, as she had been for the past two weeks. After eating, James Fosburgh testified that he read with May. The others were resting. He also spent some time with his brother, Robert S. Fosburgh. At 4:00 p.m., his brother, Robert, and his wife, Amy, went for a drive. The remaining family members walked to the Stanley Works. Robert and his wife returned before them, and the family ate their evening meal together at 6:00 or 6:30 p.m.

James Boies Alleyne Fosburgh. *Photograph from the personal collection of Beatrice Lynn Wilde.*

After that, they sat out on the porch until dark. He described reading aloud along with Robert, his mother and May. Then Miss Sheldon played the piano, and his sister May sang several sacred songs. At 10:30 p.m., his parents went to bed, followed by the other family members.

James Fosburgh related that on the night of the crime, he was awakened by a terrible shriek from his father's room. He had no idea who had made the sound. His bedroom was on the first floor, directly below that of Miss Sheldon. He got out of bed and turned on lights as he rushed up the front stairs. His sister-in-law, Amy Fosburgh, appeared before him in the light as he reached the top of the stairs. Amy screamed, "Your father's gone crazy. Your father's gone crazy!" She was in her night dress. He proceeded to his sister May's room and found her lying on the floor. He stated that there was no one else in the room. The lights were on at this time. He was positioned by May's head and straightened out her legs, which were tucked under her body. His parents appeared, followed by his brother, Robert S. Fosburgh, who staggered in and collapsed next to his sister. James Fosburgh stated that he did not know what happened to his sister or realize that she had been shot. He did know she was unconscious. He did not notice blood on her nightgown but did observe it in her nostrils. He also stated that he heard no shots. He called out for water, towels and ammonia. He quickly put on trousers and ran out of the house barefoot to call for a doctor. He claimed to be unaware of what happened until he returned. He ran to the nearby Shepardson house. While still at the Shepardson house, he heard his father call from the window, "Police! Murder! Help!" From there he ran to the Stanley Electric Works office, about two hundred yards away, to use the

telephone. The office was dark, and James called the central switchboard to have them call Dr. Roberts. Dr. Roberts and several other doctors he tried to reach could not or would not come. Dr. Walter W. Schofield in Dalton was finally reached. When he returned, his sister Beatrice placed his hands on her shoulders and said, "She is gone." Both his parents were at May's side. His mother cried, "She's gone!"

When questioned regarding how much time passed between his hearing the first scream and seeing his sister's body on the floor, the witness stated that he didn't know but then added that it was only a matter of seconds.

When asked about witness testimony that he had been observed the night of the tragedy with his suspenders hanging down, James Fosburgh bristled and responded that he hadn't owned a pair of suspenders in over five years.

James Fosburgh was asked about Miss Sheldon. He said he did not see her in his sister's room but had a "faint recollection" of seeing her in her bedroom doorway, but he wasn't completely sure.

James Fosburgh stated that he helped his father dress and was getting shoes from under the bed when he found a revolver. He said his sister Beatrice picked up an old crushed brown derby hat that he had never seen before. A patent leather shoe found by police officers on the stairway of the house was shown to the witness. He stated that it did not belong to either him or his brother. He described it as being wet and muddy when he first saw it.

The witness later gave aid to both his parents in his downstairs bedroom by applying hot compresses to their injuries.

James Fosburgh testified that at daybreak he and his brother, Robert S. Fosburgh, observed footprints outside the house and handprints on the railings. He also stated that matches found in the kitchen, bedroom, attic and carriage house were not of the type used by his family.

James Fosburgh related the story of picking up a photograph of his sister May off the floor. While placing it on the bureau, he noticed a bullet hole in the bureau. While investigating further, he found the bullet in the comb case. This event occurred sometime after the autopsy, but he was unsure of the time or to whom he gave the bullet to.

As he left the stand, James Fosburgh smiled at his brother and was heard to say, "That's through with."

Next to take the stand was Frederick W. Lund of Maynard, Massachusetts. He was the bookkeeper and paymaster of the R.L. Fosburgh and Son Construction Company. Lund was asked to identify a piece of paper with employee names on it. He could not. James Fosburgh was recalled and testified that he had written the names in September 1900.

Patrick Parker, the superintendent of detectives from Providence, Rhode Island, testified about an interview of Miss Bertha Sheldon that he conducted in Providence with General Jephanus H. Whitney of the Massachusetts State Police on September 20, 1900. Detective Parker stated that Miss Sheldon heard noises and came out of her room through the door leading to May Fosburgh's room and saw May lying on the floor with her brother beside her. Miss Sheldon related that she heard no shooting and saw no one but members of the Fosburgh family.

Captain William G. White of the Pittsfield Police Department was called to testify. He had served on the police force for twenty years. White arrived at the Fosburgh house at 2:00 a.m. and was accompanied by Officer Daniel P. Flynn. It was very dark. Robert L. Fosburgh related to him that there had been burglars in the house and they had shot his daughter. He could not describe them since they were wearing masks.

Captain White related that Robert S. Fosburgh said he was awakened by his wife and heard noises in his father's room. The defendant claimed that as he arrived at his sister May Fosburgh's room he heard two shots and was just in time to catch her in his arms. The defendant told White that he had a loaded .32-caliber revolver in the bureau, but he was certain it had been taken by the burglars.

White described a shoe that Officer Flynn had found at the head of the stairs leading to the bedroom. He testified that he saw no pillowcase until later. He searched for footprints on the balcony and nearby field but found none. The cellar window sills were each covered with dew and spider webs.

Captain White questioned Beatrice to see if she had seen any burglars, and she responded that she had not. She said when the struggle began she ran back into the room to turn on the light.

Captain White stated that Officer Flynn did not call to him from the back stairway to tell him that the door was unhooked. White said he never stated that the shoe was wet and did not receive a lantern from Mr. Shepardson.

At this point, court was adjourned for the day. After the session was closed, a spectator angrily confronted Captain White, accusing him of being a liar. Captain White remained silent and calm, but tensions were obviously running very high in the courtroom.

TRIAL DAY FOUR:
TUESDAY, JULY 23, 1901

In a stunning start to the day's proceedings, Judge William B. Stevens decided to exclude several New York City reporters from the trial. Judge Stevens stated, "There could be no more outrageous breach of propriety and nothing so calculated to prejudice the minds of the jury and the public and defeat the ends of justice." The judge further stated that "their articles concerning the case had a tendency to interfere with justice. The publishers of these newspapers are outside the Commonwealth and therefore outside my jurisdiction, but if proof were given me of the identity of the writers I would deal with them as the action deserves. It is my privilege and duty to exclude the representatives of these papers from the courtroom." The judge continued, "Mr. Sheriff, you are ordered to exclude all representatives of the *New York Herald*, *New York Journal* and *New York World* from the court. During the balance of this trial, it is my right and duty to see that these three papers are not represented here." At this point, five men and two women were escorted out of the courtroom by the Berkshire County sheriff. They were Leo L. Redding, *New York Herald*; Dorothy Dix, *New York Journal*; George B. Fyfe, *New York Journal*; John W. Low, *New York World*; Samuel A. Blythe, *New York World*; Haydon Jones, *New York World*; and Harriet Hubbard Ayer, *New York World*.

It was thought that their graphic coverage of a Fosburgh family visit to Pittsfield Cemetery led to their expulsion. (May Fosburgh's body was being temporarily stored in the Clapp Family Mausoleum.)

Judge Stevens continued his practice of inviting guests and friends to join him on the bench during proceedings. Reverend Dr. Henry M. Field and

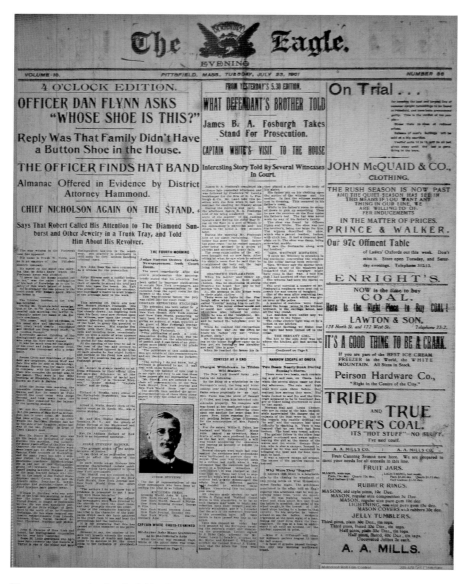

News coverage in the *Berkshire Evening Eagle*, dated July 23, 1901. *From the* Berkshire Evening Eagle.

former United States senator Henry L. Dawes spent time on the bench with Stevens. Field was a summer resident of Stockbridge, Massachusetts, and the retired editor of the *New York Observer*.

Captain William G. White of the Pittsfield Police Department was recalled to the stand. He again described that it was a very dark night. He had difficulty distinguishing individuals four feet away. The first person he met was Pittsfield police officer George E. Chapman, whom he recognized by the sound of his voice. He was asked about the shoe found on the stairs in the Fosburgh house by policeman Daniel P. Flynn. White admitted that his attention was called to overturned furniture and other items by various Fosburgh family members. He observed an out-of-place bureau mirror. He testified that his attention was brought to it when Robert S. Fosburgh told him of his missing revolver, which was stored there. He did not remember examining anything other than what his attention was called to by someone in the household. Attorney for the defense Hebert C. Joyner strongly challenged Captain White's memory on several points to which White replied that he could not recall. Captain White believed he was told that it was James Shepardson who found the revolver under the bed. While at the Fosburgh house that morning he had believed that all stories told to him were true. He did think that the narrow space between the window and the screen was a "peculiar" way for a man with a lantern and a revolver in his hands to squeeze through.

Policeman Daniel P. Flynn took the stand following Captain White. Flynn had been a Pittsfield police officer for fourteen years. (Flynn would one day become chief of the Pittsfield Police Department.) He drove to the Fosburgh house with Captain White, and they arrived at 2:00 a.m. Upon arrival, he met Officer George E. Chapman, whom he only recognized by his voice in the dark. He stated that the defendant denied that the shoe was his and that the shoe was completely dry when he found it. At the head of the stairs leading to the kitchen-bedroom were a clothes basket and several pieces of clothing. He moved these aside so he could walk down the stairs and found the shoe. There was clothing over and under the shoe when he found it. He did not believe that it had been worn outside due to the heavy dew at the time. Mrs. Robert L. Fosburgh examined the shoe and said it didn't belong to anyone in the household. Flynn stated that he found the screen at the foot of the back stairway hooked and never called back to Captain White that it was not. He also stated he did not observe any broken casters on the bed. His testimony was similar to that of Captain White. Officer Flynn also testified that he later found a hatband downstairs with the name James B.A. Fosburgh on it. It was partly covered with a rug. Flynn related that he went to use the phone at Mrs. Bertha E. Bullard's house and told her a burglary had been committed. He asked her if she had seen anything unusual, and she replied that she had not.

Mrs. E.T. Castle was called to the stand. She described the renting of her home to Robert L. Fosburgh. She was away from Pittsfield on the date of May Fosburgh's murder. By the time she returned to Pittsfield, the family had left the house. She did observe finger marks on the porch post upon her return there.

A neighbor, William R. Gardner, assistant manager at the Pittsfield Electric Light Company, testified he heard a cry of "Police!" at 1:20 a.m. He noted that he heard the screams about five times. However, he believed the sounds came from the direction away from the Fosburgh home. He jumped out of bed and grabbed his revolver before opening his window. He testified that it was "pitch" dark and there was no moon. He heard nothing more and went back to bed. He was later awoken by teams of horses riding by.

Frank J. Noble, an employee of the Pittsfield Electric Light Company, stated that there were carbon arc streetlights near the Fosburgh residence, but they were turned off at 12:30 a.m. each night. Only the lights in the center of the city remained on all night. A comical moment occurred in the trial when he admitted he had no idea exactly where the Fosburgh house was situated. "I never had the house pointed out to me," he explained. It was observed that he may have been the only person in the courtroom who didn't know where the house was located. William Gardner was recalled to confirm that the Fosburgh house was not considered to be in the central part of the city.

Dr. Schofield was recalled to the stand. He testified that he carried a lantern under his wagon as he was driven to the Fosburgh house by his driver, J. Gorden Bennett.

District Attorney Hammond produced an almanac and offered evidence of a new moon on August 24, 1900, four days after May Fosburgh was killed. The almanac was then entered into evidence, along with several pairs of shoes taken from the Fosburgh residence, as well as a bureau and window screen.

The final witness of the day was Pittsfield chief of police John Nicholson. He was said to have testified in a "careful, deliberate, and moderately slow manner which held the attention of all in the courtroom." He was first notified at his home of the incident at 2:00 a.m. by one of his officers. He immediately went to the police station. Chief Nicholson reached the Fosburgh house between 5:00 a.m. and 6:00 a.m. on August 20, 1900. He first spoke to the defendant, Robert S. Fosburgh, and his brother, James, before entering the house. They called his attention to marks and footprints on the ground. A porch post showed a hand and several distinct finger marks on it. On the balcony, Nicholson observed the dew had been removed from

the railing at the north and south ends. The roof had a mark on it as if somewhere had stepped there.

The defendant, Robert S. Fosburgh, related to Chief Nicholson that earlier his wife had heard strange noises that he attributed to a cat or rats. They went back to sleep. Shortly after, he heard loud noises and rushed into his sister's room. He saw some lights and believed that the house was on fire. Rushing toward Miss Sheldon's room for a bucket of water, he reached the door just as his sister fell into his arms. He saw a man in the doorway of the kitchen-bedroom and placed his sister on the floor before "grappling" with the intruder. At this time, he had no indication that his sister had been shot. Another man then struck him from behind, and he released his grip on the man, who then fled down the back stairway. The second and then a third man escaped through the window of the kitchen-bedroom. The defendant suggested that the man he struggled with had been a "colored man." He reached this conclusion by the feeling of his hair as they struggled. One of the men was said to have worn dark clothes, and another was clad in a faded brown suit. He also told Chief Nicholson the pistol found there did not belong to the family.

The defendant stated to the witness that a revolver had been taken that was stored under some clothes in the in the top drawer of the bureau. Robert S. Fosburgh also pointed out a hole in the hallway wall. He suggested that two shots had been fired. No bullet was located in the wall. Robert L. Fosburgh told of finding a large number of burned Diamond matches. These were claimed to be a brand not used in the house. James gave Pittsfield police chief Nicholson several of the matches. Matches continued to show up in various places for several days after the shooting.

Chief Nicholson went on to describe his investigation. He observed a dented metal Rochester lamp and broken casters on the bed in the kitchen-bedroom used by the defendant and his wife. During his initial visit, the chief stated that he was in the house for about an hour.

Chief Nicholson revisited the Fosburgh residence at 11:00 a.m. the same morning. On the way in, James Fosburgh handed him a bullet that he said he found in the bureau. During this visit, a more thorough search of the house was undertaken.

Robert L. Fosburgh also described the night of the shooting to Chief Nicholson. Fosburgh said he woke to the sight of a very tall man with a revolver in his left hand pointed toward the bed. He jumped from bed and struck the man's arm. He did not realize at that time that he had disarmed the intruder. After the burglars left, the loaded revolver was found at the head of the bed. The hat was found near his bureau. Robert L. Fosburgh

related to the witness that the two men he saw wore pillowcases over their heads. He was unsure if they wore hats either over or under the pillowcases.

The noon recess was called.

When court resumed, Chief Nicholson returned to the stand. Discussion continued regarding the broken casters and other damaged items from the house. On that subsequent visit, Chief Nicholson stated that he found the bullet-damaged night dress of May Fosburgh along with other clothing soaking in a tub of water.

The tests previously conducted by Dr. Paddock regarding gunpowder residue on clothing was discussed. In addition to Paddock and Nicholson, General Jephanus H. Whitney of the Massachusetts State Police and Brace Whitman Paddock (the twenty-two-year-old son of Dr. Paddock) were present. A half dozen squares of cloth taken from the nightgown of May Fosburgh were attached to the side of a barn and fired at from different distances with a similar Harrington and Richardson revolver. The distances tested were four inches, six inches, eight inches, one foot, two feet and four feet. The defense objected to the evidence, but it was allowed by Judge Stevens. Several individual items were also entered into evidence. The items included two pillowcases, a handkerchief and a pair of stockings. A pair of black trousers taken from a closet in the home was also entered into evidence. The trousers were identified as the defendant's and were said to have been taken from a hook in the closet of the kitchen-bedroom.

In a surprise move, at 3:35 p.m., District Attorney Hammond abruptly rested the government's case at the conclusion of Chief Nicholson's testimony, despite having several additional witnesses scheduled to appear. The defense immediately asked Judge Stevens to dismiss the case due to lack of evidence against the defendant, Robert S. Fosburgh. Stevens ruled that the court would not entertain the motion. The defense was quoted as saying that as a result of the day's stunning events "they were at a loss where to pick up the threads of the story."

TRIAL DAY FIVE:
WEDNESDAY, JULY 24, 1901

D efense Attorney Herbert C. Joyner began by addressing the court and describing the scene the morning of the tragedy. Joyner stated, "We do not know, and the government does not know, that it was the defendant's gun which shot his sister." He suggested that robbery or revenge was the motive of the burglars and that they intended to steal "anything they could lay their hands on." He went on to describe them as "young, active and slight men, else they could not have gotten out of the house through the opening left in the screen." He said men were seen running down Benedict Road at the time of the crime and suggested that the burglars simply blended in with the gathering crowd and escaped in the confusion.

Attorney Joyner related that many "non-English speaking" employees of the R.L. Fosburgh and Son Construction Company were paid in cash at the company office. These men were aware that large sums of money were transported from the bank to the office. He claimed that Pittsfield police chief Nicholson himself remarked that "if any men needed a pistol, the Fosburghs did." Attorney Joyner stated that this is why Robert S. Fosburgh purchased one.

He related that Robert S. Fosburgh and his wife, Amy, had first occupied the kitchen-bedroom but moved to another room due to an odor in the sink. They left some clothing and Robert's pistol in the bureau.

Attorney Joyner stated that the family had thrown clothing, pillowcases and other items into a basket located in the carriage house. He went on to explain that the furniture in the home was cheaply made and easily broken by the

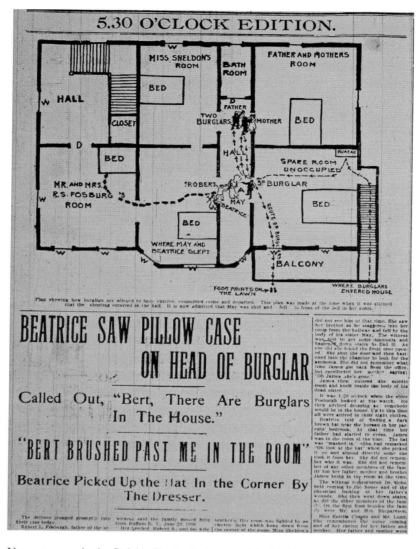

News coverage in the *Berkshire Evening Eagle*, dated July 24, 1901. *From the* Berkshire Evening Eagle.

struggle in the back room. There was a narrow opening between the bed and the bureau, which he suggested was moved around during the struggle.

Attorney Joyner concluded his opening at 10:00 a.m. by stating that the Fosburgh family had "done its utmost to bring to justice the men who entered the house."

Nine witnesses for the defense were sworn in together as a group.

Frederick S. Smith, a civil engineer, was the first to testify for the defense. He used maps and diagrams to describe the Fosburgh house and its surroundings.

Frederick W. Lund, bookkeeper and paymaster of the R.L. Fosburgh and Son Construction Company, returned to the stand. On August 20, 1900, he was boarding at the Shepardson home, approximately 250 feet away from the Fosburghs. He was awakened by Mr. James P. Shepardson, who said there was trouble at the Fosburgh house. Within five minutes, he ran to the Fosburgh residence and saw Robert L. Fosburgh in the doorway. He appeared hastily dressed. Lund stated that it was very dark. Upon learning that May Fosburgh was injured, he went to call a doctor. He stated he found James Fosburgh at the Stanley Electric Company office trying to reach a doctor and took the phone from him. He returned to the Fosburgh home about three-quarters of an hour later.

Attorney Joyner asked Lund what, if anything, Mr. Fosburgh had said when he returned to the house. In the courtroom, an eleven-minute consultation between Judge Stevens and the attorneys ensued. Judge Stevens announced that the question would be excluded. The defense objected to this decision by Judge Stevens.

Lund stated that he found himself alone upstairs in the Fosburgh house. He saw the body of May Fosburgh on the floor covered with a sheet. He testified that he went into various rooms in an unsuccessful search for ammonia. He observed that the end of the bureau in the kitchen-bedroom was about a foot away from the wall. He did not touch it.

Lund went back downstairs and was asked to build a fire, so he went into the cellar. In this task he was also unsuccessful. He testified that the cellar light was already turned on. He described seeing broken mortar and disturbed dust on a cellar window. Lund also stated that there were footprints four feet from the balcony and on the street leading toward Dalton, Massachusetts.

Attorney Joyner asked Lund if defendant Robert S. Fosburgh was in Pittsfield on July, 5, 1900, and Lund responded that he believed he was. He also stated that he saw Robert S. Fosburgh with a firearm in his possession on payday. It was on a desk along with some cash. He added that he never saw Robert L. Fosburgh with a weapon. Lund conceded that Robert L. Fosburgh was frequently away from the city on business.

Lund was shown the shoe found in the Fosburgh residence. He stated that he had never seen the defendant or the defendant's father wearing such a shoe.

During cross-examination, Lund stated that he did not see police officers White or Smith while he was at the Fosburgh home.

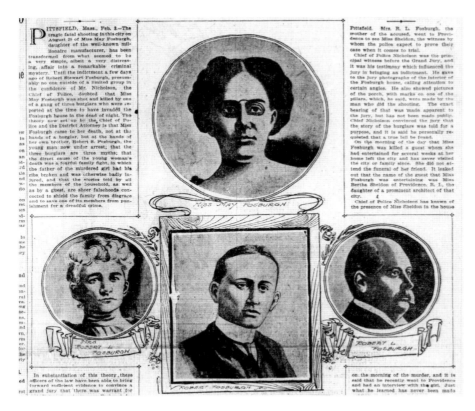

The sensational Fosburgh trial was covered in the press from coast to coast and beyond. *From the* San Francisco Call, *February 4, 1901/California Digital Newspaper Collection, University of California, Riverside.*

At 11:54 a.m., Robert L. Fosburgh, father of the defendant, was called to take the stand. He was a sturdily built and energetic man of fifty-nine years of age. He was described as one who spoke with emphasis and words that carried conviction. Fosburgh stated that he had been a contractor for fifteen years. He had moved into the Castle house on June 23, 1900. His wife and family, along with son Robert and his wife, Amy, moved in on July 1, 1900.

Fosburgh related the family's activities in the evening leading up to the tragedy. The last song May had sung was "The Plains of Peace." Upon mentioning this last song of the evening, Robert L. Fosburgh paused, his eyes filled with tears and he was unable to continue for a short time.

Robert L. Fosburgh testified that on August 20, 1900, he was awakened by his wife. He asked her what the trouble was. He then observed a light in the hallway and knew something was wrong. Fosburgh stated that two

men walked into the room toward his bed, one holding a revolver in his left hand and pointing it toward his face. He sprang up and managed to get to his feet, striking the man in the arm and knocking away the revolver. He then described being struck by a sandbag. After he revived, he got up and went into the kitchen-bedroom. He heard his daughter Beatrice cry, "Oh, Mamma, look at May, she is hurt!" Fosburgh saw his daughter May on the floor, her mother beside her and his son James at her head. Robert S. Fosburgh then entered and fell down. Beatrice brought water, and Robert L. Fosburgh threw it in his son's face. It seemed to revive him. Robert L. Fosburgh testified that he went to the front window and cried, "Police! Murder! Help! We want help!" A neighbor, Mrs. Harry Plumb, came to her window, and he told her that burglars shot his daughter May.

Robert L. Fosburgh testified that he did not realize he was hurt until it was pointed out to him. His left eye was completely closed, and the side of his face was blackened at the cheek. Both of his ears were black and blue. His knee was hurt, and he thought a rib was broken. He had no knowledge of when or how his wife was injured.

Fosburgh was shown a hat but did not think it was the same one that his daughter Beatrice had found. He was also shown a revolver that he could not identify. He was next shown the shoe found in the house and stated he had never seen it before the night of the shooting. The shoe was marked Hanan & Son. Robert L. Fosburgh stated that he was familiar with the name and had previously purchased shoes from the firm in Buffalo and St. Louis, but never in New York City. Fosburgh was asked if he was in New York City on July 5, 1900. He replied that he was in Pittsfield.

Robert L. Fosburgh stated that after May's funeral service, the family never returned to the Castle house, with the exception of Esther, who retrieved some of her personal items. The family had resided in in a suite of rooms at the Wendell Hotel ever since that day.

Fosburgh testified to hiring four detectives and offering a large reward. He indicated that the reward offer still stood.

After a recess, Fosburgh was asked if he could identify the burglars. He replied that they had pillowcases over their heads. He did not recall telling policeman White that one man had a lantern in one hand and a revolver in the other.

At this point, cross-examination was begun by District Attorney Hammond. Fosburgh testified that he had no idea how the caster on his bed had broken. He did not remember telling Dr. Schofield that one man had a lantern in his right hand and a revolver in his left.

Beatrice Alexandra Fosburgh, circa 1900. *Photograph from the personal collection of Beatrice Lynn Wilde.*

District Attorney Joyner repeatedly asked Fosburgh about pistol shots. Each time, Fosburgh replied that he had no recollection of hearing any shots. While he did not see three intruders, he had an "impression" of a third man since there was a light behind the men in the hall. He stated the burglars made no threats or demands.

Fosburgh acknowledged seeing his daughter-in-law, Amy Fosburgh, with a torn night dress.

As testimony concluded, Robert L. Fosburgh stated he knew of no hostility by any of his employees toward himself or his son, Robert S. Fosburgh.

The next witness was fourteen-year-old Beatrice Fosburgh. She had attended the trial every day since its start. Beatrice was wearing a white pique shirt and tie with a black skirt and a white straw hat. Her jet-black hair was braided and tied with a black bow. Beatrice testified that she moved to Pittsfield with her family on June 23, 1900. Her brother Robert S. Fosburgh and his wife, Amy, were boarding with Mrs. Rogers on Tyler Street until moving in with his parents. Robert owned a horse that the family often took for rides.

On the morning of August 19, 1900, she attended church with her parents. May and James Fosburgh, along with houseguest Miss Bertha Sheldon, attended a different church that morning. The family later ate dinner together and then visited the Stanley Electric Works. The family then returned home and spent the evening together. Beatrice Fosburgh's story of that day leading up to the tragedy was very similar to that offered by her father and brother James previously. Beatrice cried for several minutes on the stand after objections were rendered to her testimony about specific

readings that night by the family. The testimony was allowed on the basis that it might "have some bearing on the relationship of the members of the family among themselves."

Beatrice Fosburgh testified that her sister-in-law, Amy, was feeling ill that evening and that her sister May visited Amy's room and brought her some hot lemonade. Beatrice testified that she was unsure if the curtains separating her room from the defendant's room were open or closed. Her room was illuminated by an electric light that hung from the ceiling in the middle of the room.

Beatrice testified that she went to bed before her sister May but was awake when May came in to bed. Beatrice was later awakened by a very loud scream that she said came from the back of the house. She stated that she jumped out of bed and headed to the door behind her sister, May. The room was dark. May cried, "Oh, gracious!" as she moved toward the hallway. Beatrice testified that she saw eyes peering at her through holes cut in a pillowcase. She suddenly heard a shot and saw a flash. As she reached to turn on the light, her brother Robert "brushed" past her. Beatrice screamed, "There are burglars in the house!"

Beatrice related that two or possibly three shots had been fired in total.

May was on the floor, and her brother Robert soon collapsed beside her. She noticed blood flowing from the wound in May's chest and cried, "Oh, Mamma! Look at May." Beatrice stated that her mother cried, "Oh, they are both gone. Who will look out for Amy?" Beatrice said her brother James called out to bring water, towels and ammonia. Beatrice testified that she heard her brother James but did not see him at this moment. She went to Miss Sheldon's room and got water and towels. Miss Sheldon stood in the doorway, but she had no conversation with her. She then ran downstairs to find some ammonia. The door to the house was open, and she slammed it shut. She didn't remember when James returned from calling for a doctor. Her mother asked her father what time it was, to which he replied that it was 1:20 a.m.

James said men were coming and that they better get dressed. Dr. Schofield arrived and gave her mother some medicine and looked at her father's head. She went downstairs. Mr. and Mrs. James Shepardson, Miss M. Estelle Chapin and Mr. Frederick Lund were there.

Beatrice testified to picking up a hat in the corner by a dresser in her parents' bedroom. She stated that it was "mashed in." She picked it up and said, "Oh, look at that hat." Immediately, someone in her family took it from her, but she couldn't remember who that was. She was shown a brown hat in the courtroom but couldn't identify it.

The witness was asked if she had turned on the cellar light, which was found illuminated by other witnesses, and she denied doing do.

District Attorney Hammond cross-examined Beatrice. He was addressing several changes in her testimony from the initial inquest as well as accounts she had allegedly provided to other individuals. Beatrice denied she had any conversation upstairs with Dr. Paddock. She said she was downstairs when Dr. Paddock arrived and did not see her sister's body placed on the bed. She denied testifying that she turned on the light before her sister fell. She denied saying at the inquest that she did not know where her brother Robert was when the shot that killed May was fired. She stated she never told any person she did not see her brother Robert until he was in the hall after her sister fell. She testified she never told anyone that she didn't see a pillowcase. She recalled two shots being fired and said she saw no light in the hallway before she got out of bed.

Beatrice's testimony was over.

The next witness called was American Express cashier and neighbor James P. Shepardson. He was one of the first neighbors to arrive at the crime scene. He stated that he had not met the Fosburgh family before the tragedy. Earlier in the evening, he had sat on his lawn with boarder Frederick Lund and listened to music coming from the Fosburgh home. He retired at 10:30 p.m. That night, he was awakened by the violent ringing of his doorbell. Standing at his door was a barefoot James Fosburgh. James told him his sister was hurt and that he needed a doctor. Shepardson suggested that James Fosburgh call for Dr. Roberts. Shepardson also noted that James Fosburgh was wearing trousers, a shirt with rolled up sleeves and no hat.

Shepardson woke Frederick Lund. He then dressed and went to the Fosburgh house and saw Robert L. Fosburgh. Shepardson further testified he and neighbor Harry Plumb then went to call police officer George E. Chapman. Shepardson arrived at the Stanley Electric Company office just before Lund and found James frantically trying to phone a doctor. He took over for James and called for a doctor and notified police.

Shepardson testified that he was one of the first neighbors to enter the Fosburgh home, along with his wife, May Shepardson, and his sister-in-law, Miss M. Estelle Chapin, who lived with them. He recalled that when he arrived, Amy Fosburgh was leaning against a wall, looking "distracted." The rest of the family were grief-stricken and in a highly excited state.

James Shepardson went on to testify that it was very dark. He returned to his home to retrieve a lantern, which he said he lit and gave to Officer White.

Under cross-examination, he couldn't say if he lit the lantern and handed it to Officer White as he had previously testified. Furthermore, did not know if White personally used the lantern. He claimed to not recall telling a policeman that it was as "dark as a pack of black cats."

May C. Shepardson, the wife of James Shepardson, was the last to take the stand for the day. She relating hearing loud cries and then hearing someone say, "Oh, she is dead." She went to the Fosburgh house with her sister, Miss M. Estelle Chapin. Mrs. Shepardson thought the first man she saw at the house was a reporter, which was before the arrival of Dr. Schofield. She saw all the Fosburgh children downstairs and comforted Beatrice. She testified that she was there twenty or twenty-five minutes before the Fosburgh parents came downstairs. She aided Mrs. Robert L. Fosburgh as she came down the stairs. Mrs. Shepardson testified that Mrs. Robert L. Fosburgh stayed downstairs until she left the house. Mrs. Shepardson stated she stayed until 5:00 a.m. and never saw Dr. Paddock.

Court was adjourned for the day at 4:45 p.m.

TRIAL DAY SIX:
THURSDAY, JULY 25, 1901

Reverend Dr. Harry M. Field again joined Judge Stevens on the bench. The day's first witness was Miss M. Estelle Chapin, the sister of May C. Shepardson. Her room in the Shepardson home was on the side of the house facing the Fosburgh home. Earlier in the evening, she heard singing coming from the Fosburgh residence. She read until 12:30 a.m. and then went to sleep. She was awakened by the incessant ringing of the doorbell and soon after heard men's voices crying, "Murder! Police! Help!" Her sister entered the room, and together they knelt by the window. Miss Chapin stated that she heard a woman say, "She is gone." The witness testified that she and her sister and her sister's husband went to the Fosburgh house. The first person she saw was Amy Fosburgh. James Fosburgh met the group at the door, wearing trousers and a shirt. She saw Robert S. Fosburgh on the landing and Mr. Frederick Lund in the parlor. Robert S. Fosburgh, Beatrice and Miss Sheldon came downstairs, and the visitors were told what had occurred. Mr. and Mrs. Robert L. Fosburgh were lying on the bed in James Fosburgh's room. Miss Chapin stated that several members of the Fosburgh family were moaning and crying bitterly. The witness said she saw both Dr. Schofield and Dr. Paddock when they entered the residence. Miss Chapin stated that she stayed in the Fosburgh residence until 5:00 a.m.

Under cross-examination by Attorney Crosby, the witness claimed that she had no recollection of speaking to any of the Fosburgh family about the tragedy since that day. She did not recall the arrival of policeman Daniel P. Flynn. She thought that Dr. Paddock arrived at 2:40 a.m. She also said that

RHODE ISLAND GIRL SAW MAY LYING DEAD

Knew Nothing of Events Preceding the Shooting.

HEARD BEATRICE EXCLAIM 'BURGLARS SHOT MAY'

Tells What She Saw in May's Room On That Fatal Night.

EVIDENCE RELATING TO SALE OF SHOES IN NEW YORK

Mrs. Bullard Saw Two Suspicious Characters at Midnight in Front of Her House on Tyler Street.

"Mr Fosburgh and I went upstairs and went to bed."

"I do not know the order in which the other members of the family went to bed or when they went."

"We went to bed to sleep and went to sleep."

"The next thing I saw was a light."

Then Mrs. Fosburgh told in narrative form the story of the occurrences of the night.

Many times during the recital of the struggle with the burglars and the the death scene of her daughter, May, Mrs. Fosburgh was overcome with emotion. She told her story with dramatic earnestness and there were many tearful eyes in the court room.

The members of the family were in tears during the parts of her story which related directly to the death of her daughter.

"It was not Robert who was mask-

height, and slender build. She has a sweet, pleasant face, bright and fresh looking. She had a most captivating smile upon her face as she faced the cross-examiner.

The much talked of Miss Bertha L. Sheldon admits that she isn't an expert, an experienced player on the piano, and the admission made a laugh in the court room.

Mr. Joyner was asking her about the events of Sunday evening and she had spoken of playing the piano. Mr. Joyner innocently enquired if she was "an expert, an experienced player on the piano."

She nodded her head and said she wasn't.

On the fifth of July, 1900, Bookkeeper Lund made out six checks for R. L. Fosburgh & Son. Some were on the Greylock bank of

The much-anticipated testimony of Miss Bertha Sheldon. *From the* Berkshire Evening Eagle.

James Fosburgh was wearing shoes when she came to the Fosburgh house. She couldn't identify the type of shoes or whether they were of a cloth-top variety.

Next on the stand was neighbor Harry S. Plumb. He left his job at the Wendell Hotel and arrived home around 11:00 p.m. on the night of the tragedy. His house was the nearest to the Fosburgh residence. He testified that it was dark when he went to bed despite the stars in the sky. His bedroom faced the Fosburghs'. He was awakened by screams and then heard a pistol shot followed by another and then more screams. His wife also screamed. Plumb heard a call for help, which he thought came from Robert L. Fosburgh. He dressed and ran to the Fosburgh house. He saw Robert L. Fosburgh, who he said was wearing a nightshirt and trousers. He stated that Robert L. Fosburgh filled him in on what happened. Judge Stevens cautioned the witness and excluded the statement. Plumb stated that the family members were not dressed at this time.

Plumb eventually entered the residence with policeman George E. Chapman. The witness observed the defendant, Robert S. Fosburgh, coming downstairs with his brother, James Fosburgh. The defendant was dressed.

Plumb testified that Dr. Paddock came three-quarters of an hour after Dr. Schofield. The witness left to get a nurse, who arrived at the Fosburgh residence at 4:00 a.m.

The witness further testified that he saw a set of footprints, one apparently without a shoe. He also claimed to have seen widely spaced footprints going up the road. The prosecution objected, and the witness was cautioned by Judge Stevens.

Upon cross-examination, Plumb revealed that he had introduced Officer George E. Chapman to Robert L. Fosburgh and that Fosburgh asked Chapman to keep outsiders from the house. Around this time, police captain William G. White appeared with a shoe and a hat in his hand. He asked Officer White about the shoe and saw nothing to indicate that it was wet.

Mrs. H.S. Plumb, wife of Harry S. Plumb, was next on the stand. She related hearing singing coming from the Fosburgh residence earlier in the evening. Later, she awoke at the sound of a pistol shot, followed by another. She also heard screams and then a distressed voice calling out, "Murder, doctor, help, police!" Mrs. Plumb did not go to the Fosburgh residence until 7:00 a.m.

The next witness signaled the much-anticipated appearance on the stand of Miss Bertha Louise Sheldon of Providence, Rhode Island. She was the only non-family member in the Fosburgh home at the time of the tragedy.

Miss Sheldon stated that she was twenty-one years old and somewhat hard of hearing. She hadn't been well and said she was invited to the Fosburgh

house in hopes that the Berkshire air would improve her health. She had intended to return home to Providence sooner, but Robert L. Fosburgh wanted her to stay and see his wife upon her return from St. Louis. She resided in the guest bedroom, which led from May Fosburgh's bedroom. Attorney Joyner inquired "if she was an expert, an experienced player on the piano?" She vigorously shook her head side to side and said she was not, which brought forth laughter in the courtroom.

Miss Sheldon stated that she went to bed around the same time as May and Beatrice. She said the family kissed each other goodnight, as was their custom. The witness testified that she was awakened shortly after midnight by a piercing scream and a pistol shot. She got up, opened the door and asked, "What is the matter?" She saw May on the floor. Robert S. Fosburgh was on the floor beside her and unconscious. She also saw Mr. and Mrs. Robert L. Fosburgh and Beatrice. She asked Beatrice what happened, and Beatrice exclaimed, "Burglars entered the house and shot May!"

Miss Sheldon observed that May was breathing hard and blood flowed from her mouth. The family was in their nightclothes.

The witness returned to her room, dressed and went downstairs, where she sat up for the rest of the night.

Miss Sheldon said she spoke with Mrs. Robert L. Fosburgh about leaving. She left late that morning for Providence, Rhode Island. She was very excited and nervous and stated that she did not want to be in the way. Miss Sheldon did not attend May Fosburgh's funeral.

The witness said that she was asked to testify at the inquest, but her father refused to allow it. In an affidavit, she stated:

> *On August 2, 1900 I became a guest in the home of Mr. and Mrs. R.L. Fosburgh, at Pittsfield, Mass. and remained there constantly until August 20, 1900, and at 12:50 PM on that day I left there for home. The Fosburgh family is a loving, devoted family: there were no quarrels or bickerings among its members. I went there intending to stay only one week, but stayed 18 days. Mrs. Fosburgh was not home when I arrived there. She was at St. Louis, Missouri and did not reach home until Saturday morning, August 18, in time for breakfast. During that day we had a delightful time and in the evening we had music and played some simple games. All of the family were perfectly happy and devoted to one another. On Sunday, all the family went to church except young Mr. Fosburgh and his wife, and, as I understand, they went riding, as young Mrs. Fosburgh was not feeling well. We spent the afternoon reading and talking and also*

took a walk around the works of Stanley & Company near the house. On Sunday evening Miss May Fosburgh read to us, and then we had music on the piano and singing. I remember that as the music ceased each member of the family kissed the others and retired to their rooms. I never saw a more kindly, loving, devoted family in my life. All the family slept on the second floor except James, who slept on the first floor. I now have before me a plan of the second story of the Fosburgh house, with the names of its members marked in pencil occupying each room. This plan, as I remember the house, is correct. I know it is correct as showing the location of the bedrooms and the hall near the bathroom. On the morning of August 20, 1900, a little after one o'clock, I heard the report of a revolver, and also a person screaming. I lay listening and thinking for about half a minute, and then got up and went to my door, leading into the room of May Fosburgh. As I opened the door the electric light was burning in her room and I saw May lying on the floor right in front of me, with her feet towards the door. I don't think her feet extended into the little hall, but, they did extend to the door leading to the hall from her room. She was breathing, I think, but she was unconscious. Mrs. Fosburgh, her mother, was down on her knees trying to assist May. Young Mr. Robert S. Fosburgh was lying in May's room near the door, and, I think unconscious. His wife was leaning over him trying to assist him. Beatrice was also trying to assist May. Mr. Robert L. Fosburgh had been injured. One of his eyes and one of his ears were seriously hurt. The moment I opened the door leading from my room into May's and saw her on the floor I asked what had happened. Beatrice said: "Burglars have entered the house and killed May." All of the family had on only their night clothes. I was so excited that I did not talk to the family about the matter. The family was in deep distress. We took breakfast together about eight o'clock. I was exceedingly nervous, and didn't think I could do anything to benefit anyone and that I would only be in the way, so I concluded to come home. I took dinner with the family at noon that day and then bade them good-bye and took the train for home. I have not a shadow of a doubt that burglars got into the home and killed May Fosburgh. To my mind it is absurd to think that Robert S. Fosburgh, could shoot his sister. I did not see her shot nor did I see burglars in the house, but, knowing the family as I do, I have every reason to believe that May Fosburgh was killed by burglars precisely as the family states.

During cross-examination by Attorney Crosby, Miss Sheldon confirmed that she saw no burglars that night. She revealed that the kitchen-bedroom

had been occupied every night she had been in the house except the night of the tragedy. She said she knew very little and didn't want to return to Pittsfield to testify. This was the first time she had been in Pittsfield since the tragedy.

The next witness was Frank Perry Sheldon, the father of Miss Bertha Sheldon. He was a mechanical engineer and architect from Providence, Rhode Island, and had been a business acquaintance of Robert L. Fosburgh for the past three years. His engineering company, F.P. Sheldon and Sons, designed many large factory buildings throughout New England. Sheldon also designed the first screw threading machine. Mr. Sheldon testified that he learned of the tragedy by telephone and immediately telephoned his daughter to return home. The witness stated that he was friendly with the Fosburgh family and held no ill will against them. He felt the stress of his daughter returning to testify at the inquest would be too much for her and refused to allow her to come.

William Walter Sedden of New York City took the stand. He was a shoe salesman at the Hanan & Son shoe store at Twenty-ninth Street and Broadway. He had been selling shoes for twelve years. Sedden identified the shoe in evidence as having been manufactured in Brooklyn, New York, and sold by him at the Hanan store in New York City. Sedden testified that he sold this particular shoe on July 5, 1900. He explained that the lot number and shoe size was recorded at the time of each sale. It was easy to trace the shoes since only one pair of shoes in this size was produced in the recorded lot. He was unable to identify the purchaser.

Sedden was followed by George Bridges, manager of the Hanan & Son shoe store in New York City. He had been in the shoe business for ten years, five as the manager at Hanan & Son. Bridges produced a record of the purchase for $6.50 in cash. There was no name on the receipt. Bridges further testified that the shoe was a size eight and a half. It was claimed that Mr. Robert L. Fosburgh wore a size seven and a half shoe. The defendant was said to wear a size seven shoe. (No mention was made of James Fosburgh's shoe size.) The witness further observed that the shoe in question had some cotton stuffed in the toes. He also stated that shoes of the same size can frequently vary in length.

Frederick W. Lund was recalled with reference to business transacted at the R.L. Fosburgh and Son Construction Company office. Lund was shown two checks signed by Robert L. Fosburgh and dated July 5, 1900. He was also shown copies of letters signed by both Robert L. Fosburgh and Robert S. Fosburgh marked with the same date. He stated that he

believed that both men were in the office on July 5, 1900, though he only had a definite recollection of defendant Robert S. Fosburgh being there. Lund testified that he did not sign company checks but would often sign company letters. He stated that the defendant, Robert S. Fosburgh, often signed the company checks.

William E. Hazen, a former chief of the United States Secret Service, next took the stand. He stated that he was first employed by Robert L. Fosburgh on June 3, 1901, to investigate the murder of May Fosburgh. He explained that he and others managed to squeeze through the small screen opening in the Fosburgh bedroom in just a few seconds. He was assisted in this experiment by Frederick Lund, the Shepardsons and James Fosburgh. District Attorney Hammond objected to the testimony regarding the screen experiments but was overruled. Hazen testified that at no time while employed by the Fosburghs and during the course of his investigations had he conferred with Pittsfield police chief Nicholson. In an interview with the press, Hazen stated, "I am convinced that the crime was committed by burglars. One fact that impressed upon my mind at the onset and that was that the job was the work of beginners or amateurs."

Mrs. Bertha E. Bullard took the stand and testified that she lived on Tyler Street on August 19, 1900, and that at midnight she was up caring for her child and saw three men standing in front of her house. They spoke in loud voices. About an hour later, she heard shots, which she paid no attention to. Under cross-examination, the witness admitted that men would frequently walk by her house at that time of night. Mrs. Bullard stated that though she was acquainted with Pittsfield police officer Daniel P. Flynn and saw him early that morning, she never related to him or any other officer what she saw and heard that night. She denied that Officer Flynn asked her if she saw any strange men about that night.

Mrs. Nellie Beverly of Cheshire, Massachusetts, testified that her husband was sick and that she had to give him medicine every hour. (He died on August 25, 1900.) On the night of the shooting, she heard the fire alarm sounding. She stated that between 1:00 a.m. and 2:00 a.m. she heard two individuals running. She opened her window blinds to look outside. One or both men stopped at a tree near her home and were breathing heavily. She shouted at them to go away. She stated that they stood there for about two minutes. Her husband was extremely upset by the activity and refused to take his medicine. Upon cross-examination, she admitted that the fire alarm sounded an hour or more after she saw the men. She saw one only man running but claimed she could hear two men breathing and running. She also admitted

Esther Mair Stuart Fosburgh. *Photograph from the personal collection of Beatrice Lynn Wilde.*

frequently seeing intoxicated men walking by her home and going in the direction of Dalton.

At 2:24 p.m., Mrs. Esther Mair Stuart Fosburgh, the mother of defendant Robert S. Fosburgh, took the stand. She was dressed all in black with a long veil and wearing eyeglasses. She was fifty-one years old.

Mrs. Fosburgh stated that she retuned home on Saturday, August 18, 1900. She had been in St. Louis taking care of her father while he was ill. She was not home when Miss Sheldon arrived at the Fosburgh residence.

Mrs. Fosburgh testified that her son Robert S. Fosburgh had been married for more than three years to his wife, Amy. Robert and Amy did not live with her and her husband until three or four days before she went to St. Louis, which was in mid-July. James arrived at the house on July 3, 1900. Esther was away visiting in Adams, Massachusetts.

The witness was asked about the family activities on Sunday, August 19, 1900. Amy was feeling ill that day and asked the defendant to take her for a ride. After attending church, the family changed clothes and paid a visit to the Stanley Works. They left the doors unlocked while they were away. Later that evening, she read to the family from a book, followed by May and James Fosburgh. May read a book about wild animals. Next, Miss Sheldon played the piano, and May sang "The Holy City," Rudyard Kipling's "Recessional" and "The Plains of Peace."

The witness and her husband then went to bed for the night. Mrs. Fosburgh wasn't sure in what order her other family members went to bed.

Mrs. Fosburgh explained that she slept with her bedroom door open and was awakened by a light. She asked, "Who is it? Who is it?" She expected to see one of her children going to the bathroom. She then observed two men wearing masks and "looking like devils." She woke her husband and screamed.

Mrs. Fosburgh stated that she clutched one of the men. She stated that both she and her husband were in an intense struggle with the intruders before they fled the room. She estimated that the intruders were in her bedroom in excess of half a minute. Her impression was that the burglar could have fired his gun had he wished before her husband was able to disarm him. She stated that the intruders hurriedly left once her husband got the best of them. The witness next heard Beatrice exclaim, "Oh Mamma, look at May!"

At this point, the witness was hysterically crying on the stand. Many in the courtroom also had tears in their eyes.

She eventually continued by saying that she saw May on the floor and her son Robert beside her. She asked, "Are both my children gone?" Someone answered, "I'm afraid they are."

The witness went to her daughter May's side. She put her fingers to May's mouth, which was gushing blood. At this point, she saw Miss Sheldon in the doorway and cried for her to get towels and water. They were finally brought by Beatrice. The defendant, Robert S. Fosburgh, tried to get up, but the witness told him, "Don't get up, I can't lose you both."

Mrs. Fosburgh stated that she couldn't remember seeing her son James until he returned to the house. Upon his return, she heard him say that they must get dressed. The defendant was rocking beside his sister saying, "Oh, why wasn't I taken?"

The witness said she was trying to fix May when Dr. Schofield arrived. He told her to leave her as she was.

Mrs. Fosburgh said she did not see Dr. Paddock until breakfast. She stated that Dr. Paddock was mistaken in saying he saw her that evening. While she claimed that a great many things happened that evening that she could not remember, she was certain she did not speak to Dr. Paddock or to the police officers. Despite her strong objections, she knew an autopsy would be performed and at breakfast told Dr. Paddock, "My girl was good. My girl was pure. You will treat her as if she were your own."

The nurse told her that she had a stiff neck and that the burglars must have tried to choke her. She hadn't realized that she was injured. She denied ever stating that she had lost consciousness. The witness also denied telling Dr. Paddock that she did not know how she was injured and that she had not seen any burglars. She further emphasized that she never told anyone that she didn't see intruders.

The witness testified that she hadn't seen her son Robert until he came into the room and fell to the floor. She also said that it wasn't Robert who was masked.

Upon cross-examination, District Attorney Hammond questioned the witness further about whether she had seen or spoken to Dr. Paddock prior to breakfast. Mrs. Fosburgh once again denied it and stated that Dr. Paddock was mistaken.

Mrs. Fosburgh speculated that the light she saw was made by matches. She had absolutely no knowledge of how the burglars left the house. She said she may have ripped the pillowcase mask off the man she struggled with and that the hat was found where they had struggled. She had no recollection of her son James going for a doctor.

Finally, the witness was asked if she told Dr. Paddock that there were troubles between the defendant and his wife and that Robert had married "below his station." She strongly denied making any such statements. Judge Stevens excluded the question and its answer.

Mrs. Fosburgh testified that she heard nothing of Amy Fosburgh's nightgown being torn. She claimed it was her nightgown that was torn.

The witness confirmed relating to Dr. Paddock that Amy was nervous and wanted to go home to her mother. But she denied telling him that "Amy should have pursued a different course of conduct toward her husband."

The defense rested at 3:30 p.m. without putting the defendant or his wife on the stand.

The state called a few witnesses in rebuttal. Miss Mary Bristol, the stenographer at the inquest, read passages from her notes. She related that Beatrice Fosburgh testified she did not think it was the first shot that killed her sister. She had no idea when the first shot was fired. Robert L. Fosburgh testified at the inquest that the first shot was fired in his room and the second before burglars left his room.

Joseph W. Hollister, a *Berkshire Eagle* reporter, stated that Robert L. Fosburgh told him he saw light in the hallway that evidently came from a lantern. The light was too steady to have come from a match. Fosburgh also told Hollister that the burglar held the revolver in his left hand.

Court was adjourned until 9:15 a.m. the following day.

Recessional

God of our fathers, known of old—
Lord of our far-flung battle line—
Beneath whose awful hand we hold
Dominion over palm and pine—
Lord God of Hosts, be with us yet,
Lest we forget—lest we forget!

"Rudyard Kipling's Recessional," a musical arrangement sung by May Fosburgh the evening preceding her death. *Author's personal collection.*

The tumult and the shouting dies—
The Captains and the Kings depart—
Still stands Thine ancient sacrifice,
An humble and contrite heart.
Lord God of Hosts, be with us yet,
Lest we forget—lest we forget!

Far-called, our navies melt away—
On dune and headland sinks the fire—
Lo, all our pomp of yesterday
Is one with Nineveh and Tyre!
Judge of the Nations, spare us yet,
Lest we forget—lest we forget!

If, drunk with sight of power, we loose
Wild tongues that have not Thee in awe—
Such boastings as the Gentiles use,
Or lesser breeds without the Law—
Lord God of Hosts, be with us yet,
Lest we forget—lest we forget!

For heathen heart that puts her trust
In reeking tube and iron shard—
All valiant dust that builds on dust,
And guarding calls not Thee to guard,
For frantic boast and foolish word,
Thy Mercy on Thy People, Lord!

Rudyard Kipling
1897

THE VERDICT

O n Friday, July 26, 1901, the courtroom at Berkshire Superior Court was full of spectators anxious to hear final arguments in the Fosburgh case. Defendant Robert S. Fosburgh and his immediate family were accompanied by several friends and relatives. Among those in attendance with the family were Miss Bertha Sheldon and her mother from Providence, Rhode Island; Mr. and Mrs. William H. Plunkett and Mrs. Caldwell Plunkett of Adams, Massachusetts; Mrs. W.J. Sloan of Buffalo, New York (the mother of Mrs. Robert L. Fosburgh); Attorney Seneca N. Taylor; and James Stuart of St. Louis, Missouri.

A startling development then occurred that brought the trial to a sudden and unexpected conclusion. Judge William B. Stevens arrived in the courtroom and ordered the defendant, Robert S. "Bert" Fosburgh, acquitted of the charges before him. There would be no jury deliberation on the matter.

Judge Stevens made the following statement:

> *Mr. Foreman and gentlemen: During the* [past] *six days we have listened to a painful recital of one of the saddest tragedies ever presented to a jury. A beautiful young girl, just budding into womanhood, was shot down in her own home. Her brother was accused of the crime. It was necessary for the government to prove three things. First, that May Fosburgh was not shot by burglars. Second, that she was shot by her brother to the exclusion of the possibility that she was shot by any other member of the family. Third, that the act was a criminal act.*

FOSBURGH FREED

SENSATIONAL MURDER TRIAL ENDS SUDDENLY

Judge and Jury Hold Fosburg Guilt-less of Charge of. Murdering His Sister

From the Berkshire Evening Eagle.

Judge Stevens stated that the trial had been fairly conducted by both the prosecution and the defense and that the chief of police had done his duty in trying to determine the truth. He went on to say that a great deal of evidence was introduced and admitted without objection that may otherwise have been excluded under strict rule of law. He then declared, "Now Mr. Foreman and gentlemen, a motion has been made that this case be taken from the jury, and it becomes my duty to say to you that, in the opinion of the court, the government had not furnished proof sufficient to sustain a verdict of guilty against the defendant, and therefore, under direction of the court, in the indictment of Robert S. Fosburgh for killing his sister, you will return a verdict of not guilty." The defendant stood while jury foreman Edwin F. Barnes was asked for his verdict. He replied, "Not guilty." Robert S. Fosburgh sank to his seat and put his arm around his mother and his head on her shoulder. The family burst into tears. Tears freely ran down the cheeks of Robert S. Fosburgh. The defendant was formally discharged, and Judge Stevens thanked the jury. He spoke of the great public duty they had performed and his confidence had the case gone to jury that they would have rendered a just verdict. He hoped their experience on the jury was

VOLUME 10. PITTSFIELD, MASS., FRIDAY, JULY 26, 1901

R. S. FOSBURGH'S TRIAL ENDS IN ACQUITTAL

Verdict of "Not Guilty" Ordered by Court and Returned By Jury.

"GOD'S INFINITE LOVE HAS SUSTAINED US."

Fosburgh Family Issue Signed Statement To The Public.

THREE THINGS FOR COMMONWEALTH TO PROVE

Fosburgh Family Receives Friends at The Wendell—Chief Nicholson Says As the State Is Satisfied, He Supposes He Will Have To Be.

ARRAIGNMENT OF LEARY

WILL PROBABLY OCCUR MONDAY MORNING BEFORE JUDGE TUCKER.

HEARING WILL BE POSTPONED TEN DAYS

PRISONER MAKES PUBLIC STATEMENT AS TO HIMSELF.

Daniel Leary, alias Michael Welsh, will within a few days be arrested on a charge of murder.

The complainant is Charles W. Fuller, sheriff of Berkshire county.

The arrest will be made by one of Sheriff Fuller's deputies and the arraignment will be before Judge Tucker in the district court, probably Monday morning.

Leary will be charged with the murder of James W. Fuller. A plea of guilty will not be excepted and all the rights of the prisoner will be reserved.

A hearing will not be held in connection with the arraignment Monday but a postponement of a week or 10 days will be asked for.

MR. FULLER'S FUNERAL.

The funeral of Mr. Fuller, Leary's victim, will be held tomorrow afternoon at 2 o'clock from the residence of his son, Sheriff C. W. Fuller at the jail. The services will be conducted by Rev. W. L. Genmner of the German Lutheran church and Rev. C. L. Leonard of the Methodist Episcopal church.

ANOTHER CLUE IN FOSBURGH CASE

CAPTAIN TITUS FORWARDS AFFADAVITS TO THIS CITY.

MISTRESS OF WELL KNOWN THIEF TALKS

SWEARS THAT SHE BELIEVES THAT LON GRAY, FROM HIS ADMISSIONS TO HER, KILLED MAY L. FOSBURGH.

Captain George F. Titus, chief of the Detective Bureau of New York, is of the opinion that he is on the track of the man who shot Miss May L. Fosburgh in this city on the morning of August 26, 1900, and for whose death her brother, Robert S., has been under indictment for six months, he became a verdict of not guilty.

Captain Titus has been having interviews with a woman who thinks she knows who killed this young woman and who gives the name of the man and says he was a burglar. Affadavits by this woman were secured by the New York police captain and yesterday forwarded to Chief of Police Nicholson.

These affadavits were received here this morning by registered letter. When presented to Chief Nicholson by a mail carrier they were refused. Chief Nicholson's reason for so doing

News coverage in the *Berkshire Evening Eagle*, dated July 26, 1901. *From the* Berkshire Evening Eagle.

a pleasant one. The jurors were dismissed. The trial was over. Robert S. Fosburgh was a free man.

Pandemonium broke out as cheers and applause were sounded within Berkshire Superior Court. Judge Stevens jumped to his feet and sternly raised his finger and instructed the sheriff to see that the outburst wasn't repeated. He said, "Mr. Sheriff, you will look to it that no such demonstration as that occurs again!" Still, a large crowd surged forward to congratulate and shake hands with the smiling Robert S. Fosburgh.

One member of the Fosburgh family was not present to see the defendant acquitted of the crime with which he had been charged. Absent from the group was Amy Sloan Fosburgh, who was reported to be "rather frail and whose nerves had given away somewhat during the last days of the ordeal." She was said to be ill at the Wendell Hotel.

The Fosburgh family released the following statement:

> *We are glad the trial has ended. We never had a moment's doubt of the result. We knew we had told the exact truth as to the death of our dear May. Her death at the hands of a burglar was a crushing blow to us all, but greater still was our anguish when one of our number was accused of killing her. But through it all God's infinite love and power has sustained*

us. To that portion of the public press and the kind friends who have nobly stood by us we extend our sincere thanks.

Defense Attorney Charles E. Hibbard said, "There is but little to say. I was not surprised in the least. I think that if the defense did not put in any evidence, the outcome would have been the same. There was no evidence whatever to connect the defendant with this crime, and the court would undoubtedly have ordered a similar verdict if the case rested when the prosecution put in its evidence." It was claimed that defendant Robert S. Fosburgh was completely unaware that final arguments might not be made until just five minutes before Judge Stevens entered the courtroom. Even so, at no time did he have any doubt of his eventual acquittal.

Several of the jurors were interviewed post-trial by the press and indicated that given the testimony and evidence that was offered they would have reached the same conclusion if they were allowed to deliberate. The jurors were collectively paid $768 for their services by the Berkshire County treasurer.

Attorney Seneca N. Taylor of St. Louis, Missouri, a close family friend of the Fosburghs, stated:

> *The Fosburgh family is one of the kindliest and most lovable I ever knew. The killing of their daughter by burglars paralyzed them. They were desirous that the murderer should be arrested and punished, and to this end they furnished all the information they possessed to Chief Nicholson. They employed private detectives to assist him in ferreting out the murderers. They never supposed for a moment that he doubted that burglars had entered their home and killed Miss Fosburgh, and from the overwhelming evidence that was placed before Chief Nicholson, as to the circumstances attending the death of Miss Fosburgh, I cannot believe he had any grounds for doubting statements of the family as how Miss Fosburgh was killed.*

William E. Hazen, the former chief of the United States Secret Service who was hired by the Fosburghs to locate the murderers, offered this comment:

> *I am convinced that the crime was committed by burglars. One fact was impressed upon me at the onset and that was that the job was the work of beginners or amateurs. In all my experience of twenty-two years I never knew a job done by professional burglars which had the characteristics of*

this one. No professional burglar thinks of using his revolver excepting as a last resort and when he has no other means of escaping capture. That the revolver was used, as well as well as other considerations, makes me certain that the housebreakers were what we call "road men," rather than professional thieves. Men who belong to this class of thieves rarely go armed. Entering the Fosburgh house, they would have taken the revolver they found there and would have made the pillowcase masks which were afterward found. That matches were used to enable the intruders to find their way about the house is also an indication of the amateur character of the work. A professional burglar would have had a dark lantern. I think there were certainly two men in the house, and probably three. They made their way in deliberately and in such a way as to increase the chance that they would be detected. Once inside, they wasted more time in making the masks. Mr. Fosburgh will not rest satisfied until the murderer has been found and brought to justice. With him, it is not a matter of dollars and cents. So far as my investigations have gone, I am encouraged by the result, but I cannot now tell what we are doing.

Robert L. Fosburgh, in speaking with reporters, offered: "My daughter-in-law, Amy, is very ill this morning. She wished to see you all, but she is not able. She asked me to say for her that she appreciated the many friendly words said by you for her husband."

The *New York Herald* published the following statement by Robert S. Fosburgh:

To the Editor of The Herald: *Had I alone been on trial before the world, I would accept my decisive vindication without comment; but it has not been so. My father and mother, my wife, sisters, brother, and, in a manner, all our relatives and friends, have been forced into a defensive position by the unwarranted enmity of the police officials in Pittsfield. That is why I consent to discuss, finally and briefly, the case which had just closed. The fair minded public long ago recognized that an injustice was threatened and determined to weigh me against my accusers. In one sense there has been a great court of inquiry, and the verdict rendered in my favor carries with it another verdict—one of disapproval and censure for those who heaped grief and suffering on a family already deeply bereaved by the loss under distressing circumstances of one of its best loved members. The world now knows the truth. But it is not within the powers of the world to give back to us my sister May. There could have been no other end to my trial. There has never been a minute when every member of the family and my host*

of friends were not confident of my acquittal. The story that a burglar, or some other intruder in our home, killed my sister is true. The case they attempted to establish against me was based entirely on theory and created out of impossible, circumstantial evidence. I have been told, and I believe that the reason for this prosecution is found in the criticism of the inaction of the Chief of Police and in our engaging outside detectives to aid in tracing the burglars. When this indictment was found against me last January, my family issued a statement to the public asking judgment be suspended until our side of the case had been heard, as the charge against me was absolutely unjust and unwarranted. When the inquest was held each of us told our stories and we had no idea that any other thought existed that our stories were true. The grand jury sat, and portions of the statements made by us at the inquest were read. Apparent discrepancies were called to the attention of the grand jury, and such witnesses as the chief of police desired to be heard, were heard. No member of our family was called before the body. No thorough or searching investigation was made. Our nearest neighbors—those who knew the most about the tragedy and who were in house within five minutes after the shooting—were not called. It was a one-sided affair, and my indictment came to me as the greatest surprise of my life. In my long ordeal the great sustaining power has been my family. They believed in me. They all knew how false the stories were. My relatives rallied around me. My friends, and I am proud to say that I have many, have stood by me. They have made it a common cause and are rejoicing with me today that the false theories of the chief of police have been destroyed. The investigation of the authorities since the indictment has cost the county thousands of dollars and has not resulted in a scrap of evidence, because none exists. They have ransacked the country from one end to the other for evidence of family quarrels and they could not produce on the stand the story of even one quarrel, nor a motive, nor a trace of one. Then they take an old hat, a shoe, a few articles of clothing, some burned matches, two tracks on the ground, and say—on this evidence, on the strength of this proof alone and because the story of every member of our family, awakened in the dead of night to grapple with masked burglars, does not tell to the hairline just where each burglar was and where each shot was fired, because one story differed the merest trifle from another—because of these damning facts we will have Robert Fosburgh indicted for killing his sister. Was there ever a greater outrage under the name of the law? It has been a matter of satisfaction to me that the great newspapers of this country have sent special representatives to Pittsfield to investigate and report this trial. So far as I know, without an exception, these trained newspapermen, after investigation, concluded that the story told

by myself and my family contain nothing but the truth, and that my indictment was unwarranted.

Pittsfield police chief John Nicholson was heavily criticized in the national press for bringing forth the charges against Fosburgh in the first place. The *New York Times* was particularly harsh in its coverage:

> *Facts had been placed before Chief Nicholson and yet, failing to arrest the invaders of the Fosburgh home, he caused the eldest son to be indicted on the charge of manslaughter. Every person present at the trial expressed the conviction that the evidence produced by the Commonwealth was not such as would warrant any Grand Jury in finding an indictment, and the question arises how the chief succeeded in obtaining an indictment and what were his motives for doing so. It looked as if at the bottom of this prosecution there was malice against the Fosburgh family, coupled with a desire to stay criticism against the Chief because of his failure to find the burglars.*

Chief Nicholson responded to Judge Stevens's decision by stating that "as the state was satisfied, he supposed he would have to be." He also said, "I knew before the trial began just what we should have to run up against in this case." The chief denied having ill feelings toward the Fosburgh family. He said he had only done what he believed was his job as a police officer. He gathered evidence and presented it to the grand jury for its consideration. He stated that "if there was any hard feeling, it was not on my part." The *Boston Globe* reported:

> *The chief made a rather good impression on the stand as he appeared so reluctant to offer testimony that he was not asked to give. It was evident he was doing his utmost to show that he had no resentment, no spite, nor bitterness toward the Fosburgh family. They and their friends feel very bitter toward Mr. Nicholson and have no hesitation in declaring that he persecuted them, that he sought to disgrace and dishonor them because he felt injured and insulted because Mr. Fosburgh secured detectives last summer. They declare that this case will end the influence of Mr. Nicholson.*

Pittsfield mayor Hezekiah S. Russell and the Pittsfield City Council received numerous communications from across the country calling for the dismissal of Chief Nicholson. Mayor Russell responded with an open letter:

It is only fair to state, after a crime was committed, the chief of police only did his duty in gathering all the evidence bearing upon the case. This evidence was obtained with the assistance of the state detective force and submitted to the district attorney. An inquest, secret of course, was held by a judge of the district court. The evidence at the inquest was submitted to the grand jury, which, upon that evidence, found an indictment against Robert S. Fosburgh. Not until after the indictment was an arrest made. How, or wherein the chief of police exceeded his duty is difficult to see.

The *North Adams (Massachusetts) Herald* editorialized:

Chief of Police Nicholson is receiving a scoring on the part of many of the newspapers that he hardly merits. He secured a certain amount of testimony in the Fosburgh case and it was laid before the grand jury. They considered this testimony sufficient evidence to warrant an indictment...There is no reason for claiming that Chief of Police Nicholson did either less or more than his duty. In fact, he seems to have been actuated by motives that should not be questioned. Had he done anything less, he would have been blamed and justly.

The *Springfield (Massachusetts) Republican* stated, "When all is said and done the Fosburgh trial and the investigations preceding it have left untouched the principal thing it was hoped would be established, the naming of the murderer. He has eluded the grasp of the authorities, probably forever, and slipped out into the dark...and left us with one more murder mystery."

In its "City Notes" column, the *Berkshire Evening Eagle* printed:

The
Fosburgh
Trial is
At an end and
The public must now
Look elsewhere for sensations.

IMPLICATING OTHERS

Who were these mysterious burglars, if indeed they had ever existed? Robert L. Fosburgh stated that he hired four private investigators in a fervent attempt to solve the crime. Seneca N. Taylor, a former criminal attorney from St. Louis and personal friend of Robert L. Fosburgh, went to Pawtucket, Rhode Island, supposedly looking into the "Wire Gang" of thieves alleged to have been in the vicinity of Pittsfield the night May Fosburgh was killed. John P. Connor, a Pinkerton detective, was hired to conduct an investigation. Detective Arthur Sherman from Rhode Island accompanied the Fosburgh family at the trial. In addition, William E. Hazen, a former chief of the U.S. Secret Service, was hired to investigate the murder. Robert L. Fosburgh also offered a reward of $1,500—well over $40,000 in today's dollars. The City of Pittsfield also offered a $1,500 reward. No one ever claimed the rewards.

Robert S. Fosburgh insinuated that their home's domestic servant, Mrs. Collins, had been seen under the influence of alcohol and that there were tramps or hobos around the house that "might be in league with her." (Household servants did not reside in the house at night.)

At one point, Robert S. Fosburgh stated "that from the feeling of the hair of the man he had grappled with that he was a negro. The hair felt curly."

Fred W. Lund, bookkeeper and paymaster of the R.L. Fosburgh and Son Construction Company, testified that he considered the workers employed by Fosburgh to be very dangerous men because "men of this class, laborers, carried weapons." There was also mention in the newspapers alleging that

the company was having difficulty with labor unions. The majority of the laborers in Pittsfield working for the Fosburghs were Italian immigrants. Smaller numbers were represented by other ethnic groups, including the Irish. Recently arrived Italians throughout the United States often found livelihood in the ranks of unskilled manual labor. Through both preference and necessity, these laborers were often engaged in seasonal construction work. During this period in history, it was not uncommon for Italian immigrants to be treated with suspicion and considered radical anarchists and pro–labor union rabble-rousers. The "Italian as a criminal" myth was widespread even though statistics have clearly demonstrated that their crime rate was virtually the same as the rest of the general population. During this era, Italians were lynched in the South, as were blacks. Over one million Italians were in the United States at this time, and many found a sentiment of cruel religious and ethnic bias. Newspapers of the time wrote with great concern about the growing number of immigrants, particularly Italians. This hostility carried over into the workplace. Between 1897 and 1904, union membership jumped from less than a half million to over two million members. Italian immigrants often participated actively in labor unions for economic reasons. Despite the erroneous negative perception, the Italian immigrants were a vital part of labor and the working class in Pittsfield and the nation.

William Lewis Gray—a former sailor on the ship *Tallahasse* docked in Hoboken, New Jersey—foolishly bragged to a female acquaintance, Olive M. Gray, that he was involved in the murder. It was confirmed that William Gray was not in Pittsfield at the time of the tragedy. He was said to have been working at a fruit farm near Union Pier, Michigan, on the night in question. Gray's potential involvement in the Fosburgh case was heavily publicized during the trial and likely helped to unravel the district attorney's case against Robert S. Fosburgh. Captain George F. Titus, chief detective of the New York City Police Department, claimed to the press that he might be able to "clear the charge of manslaughter resting against Robert S. Fosburgh." After reading in the newspaper that he was a wanted man, Gray turned himself in to Titus and made a statement. It said in part:

> *Olive Handaside, otherwise known as Olive Gray, I first met in Springfield, Mass., when I was employed on the steamboat* Mascot. *I have heard the statement made by this woman to Captain Titus and the truth is this: The statements she made that I told her are partly true. I was "stringing" her and fooling with her. I did tell her that I committed a robbery and had to*

get away…She was a woman who worshiped a man who appeared to be desperate, and as I was getting money from her, I wanted to appear to be desperate and strung her along. I wanted to be desperate in her eyes, and told her I had committed a robbery and fired a shot. There is absolutely no truth to the statements that I made to her.

Captain Titus sent the woman's affidavit by registered letter to Chief Nicholson, but it was refused. Chief Nicholson stated that Captain Titus had plenty of time to send him the information before publicizing it in the press. For that reason he would leave the matter in the hands of Captain Titus. After the trials ended, Chief Nicholson was asked if he would follow up on William Gray as a suspect. He stated, "No—it's a fake. We shall not hear anything more of that kind of story around here." Captain Titus was later quoted as saying, "I have no apology to make for the Gray case petering out." Gray was officially exonerated after the conclusion of the Fosburgh trial.

At the end of the trial, the Fosburgh family wanted Michael "Dirty Dick" Quinn, a member of the Smith-Patterson-Hacket gang of thieves, to be investigated as a suspect in May Fosburgh's murder. During the trial, Defense Attorney Herbert C. Joyner made an unexplained reference to the Patterson-Bly-Quinn "Wire Gang." The two alleged gangs mentioned are likely one in the same. During a portion of the trial, Quinn was in residence at the Medford Inn in Medford, Massachusetts, staying there in seclusion under apparent direction from the Massachusetts State Police. He was not under arrest. Apparently, neither the defense nor the prosecution in the Fosburgh case thought that Quinn could contribute anything to the case. District Attorney John C. Hammond reported:

I may say that I do not see anything in this case that would make it possible to use the testimony of Quinn. I mean that there is nothing already in evidence or that I anticipate no evidence during this trial that would make Quinn a witness for the government. I know of no such way in which we could introduce the testimony of Quinn or the other members of the Wire Gang. If we had them all here we could not put them on. I anticipate no way which they will appear as witnesses. Chief Nicholson stated: "Quinn has no connection with the case, and I know of no way in which his testimony on the stand would be competent. The government could not use him and would not use him if he were here. We have not got him in hiding, nor has the government any witnesses in concealment. I do not see how Quinn could be used in rebuttal even if the defense should undertake to show that he

was in Pittsfield last August. There is nothing to show that he was at the Fosburgh house at the time May Fosburgh was shot. If testimony should be introduced tending to show that he was in Pittsfield at the time it does not follow that he had any part in the homicide. Quinn is not a man with a record, as I understand a record, that is, he has never been convicted of any state prison offense. That is what we call a record here. Why, I could name a number of men in this city with much worse reputations than that of Quinn, who were here the night Miss Fosburgh was shot. It does not follow that they had any connection with the crime. So we could not use Quinn for the government, and he is not a witness within my knowledge.

The defense also indicated that it was not after Quinn and had no interest in bringing him to Pittsfield. Quinn was a colorful character who seemed to enjoy playing around with the press and anyone else who would care to listen to him. To a member of the press, who asked him where he'd been, Quinn replied, "Where have I been? Wouldn't you like to know! I don't know myself!"

After conducting a major manhunt and following all leads, police investigations were fruitless in finding evidence of intruders in the Fosburgh's Pittsfield home the night of May Fosburgh's death.

The Holy City

Last night I lay asleeping,
There came a dream so fair;
I stood in old Jerusalem
Beside the temple there.
I heard the children singing,
And ever as they sang,
Me thought the voice of angels
From heav'n in answer rang;
Me thought the voice of angels
From heav'n in answer rang.
Jerusalem! Jerusalem!
Lift up your gates and sing,
Hosanna in the highest!
Hosanna to your King!
And then methought my dream was chang'd,
The streets no longer rang,

"The Holy City," a musical arrangement sung by May Fosburgh the evening preceding her death. *Author's personal collection.*

Hush'd were the glad hosannas
The little children sang.
The sun grew dark with mystery,
The morn was cold and chill,
As the shadow of a cross arose
Upon a lonely hill,
As the shadow of a cross arose

Upon a lonely hill.
Jerusalem! Jerusalem!
Hark! How the angels sing,
Hosanna in the highest!
Hosanna to your King!
And once again the scene was chang'd,
New earth there seemed to be;
I saw the Holy City
Beside the tideless sea;
The light of God was on its streets,
The gates were open wide,
And all who would might enter,
And no one was denied.
No need of moon or stars by night,
Or sun to shine by day;
It was the new Jerusalem
That would not pass away,
It was the new Jerusalem
That would not pass away.
Jerusalem! Jerusalem!
Sing for the night is o'er,
Hosanna in the highest!
Hosanna forevermore!

Words: Frederick E. Weatherly
Music: Stephen Adams (alias Michael Maybrick)
1892

MODERN FORENSIC SCIENCE

Today, law enforcement officers undergo extensive training regarding the proper protection of a crime scene. This typically begins with the arrival of the first police officer. It is vital to keep evidence from being tampered with and uncontaminated until it can be thoroughly analyzed. The pristine condition of this evidence is critical to the successful prosecution of a case.

In the days since May Fosburgh's death, countless improvements have been made regarding the tools available for professionals to investigate crimes. Analysis of fingerprints, blood, DNA (deoxyribonucleic acid) and lie detector testing often find their way into modern investigations.

Fingerprint analysis allows the identification of those present at a crime scene, both suspects and victims. Today, several varied techniques exist to lift fingerprints from a crime scene, including fingerprints invisible to the eye and deposited on various surfaces. Additionally, footwear analysis can be a valuable tool. Unfortunately, footwear evidence is easily destroyed "under the feet of curious onlookers and untrained police personnel before it can be properly secured."

Blood external to a body can tell a story. Unseen blood traces can be revealed by using chemicals such as the fluorescent compound luminol, which causes blood to glow blue when exposed to ultraviolet light. The illuminated blood samples can then be collected for further testing.

DNA analysis uses biological materials such as blood, skin and sweat. These materials are used for typing, which may link a suspect to a crime or

exclude the innocent. Today, literally hundreds of thousands of DNA tests are done in the United States annually.

In the case of shootings, all firearms etch distinctive markings on the bullets that they fire, allowing them to be firmly linked or excluded from a crime. The evaluation of gunshot residue figures routinely these days in shooting investigations. The amount and scatter of residue provides information on how close a victim was to the fired weapon. A discharged firearm also deposits residue on those present at the scene of the crime. Individuals suspected of having fired a weapon are contaminated with a back-spray of residue, which can remain and be detected for some time despite repeated washings.

The potential role of alcohol or drugs in a crime should always be considered. Blood alcohol levels are easily checked today through the use of the modern breathalyzer or a simple blood test.

While it is difficult to precisely pinpoint the exact time of death, professionals often use core body temperature and rigor mortis to make their determination. Under ideal conditions, a dead body will lose approximately two degrees Celsius in core body temperature after the first hour and one degree Celsius per each additional hour until it reaches ambient temperature.

The lie detector, or polygraph, can be a useful tool, though its use is not without controversy. The device measures pulse, blood pressure, skin conductivity and respiration while the subject is asked a series of questions. Physiological responses are used to detect deceptive answers. There is some question to the validity of polygraph testing. It is said that the test cannot distinguish whether recorded anxiety is caused by dishonesty or by some other factor.

EPILOGUE

Was there enough evidence to convict Robert S. "Bert" Fosburgh in the death of his sister May Fosburgh? Clearly, there were glaring inconsistencies in the stories presented by various family members. The crime scene was not properly secured, allowing far too many people to handle and mishandle vital evidence. Innumerable questions and contradictions went unchallenged. Valuable time would pass before authorities were admitted into the house. The use of modern techniques could certainly have drawn a firmer conclusion to the tragedy, one way or the other.

During this era in New England, tremendous growth was tied to the railroads, manufacturing and banking. Many fast-growing cities such as Pittsfield relied on manufacturing as their foundation. Those of power and privilege were routinely held to far different standards than the less fortunate members of society. The class system in the United States was heavily based on profession, wealth, education, family history and social and business connections. It appears in this particular case that wealth and social prominence may have outweighed the pursuit of true justice. One publication, the *Independent*, had another view: "The guilt of the defendant was entirely in the minds of a credulous sensation-loving public, quite cocksure of its moral convictions and absolutely guileless of any comprehension of judicial proof."

According to press reports, Robert S. Fosburgh and his wife, Amy, left Pittsfield the day after the trial to stay in a cottage they had built in Maynard, Massachusetts. Fosburgh reportedly told a friend that he hoped never to

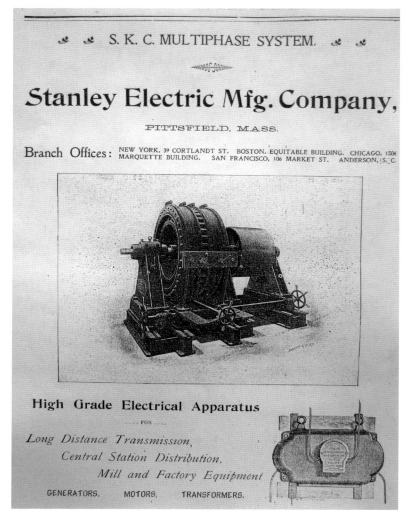

An early advertisement for Stanley Electric Manufacturing Company. *Berkshire Athenaeum Local History Department Photo Collection.*

return to Pittsfield again. Robert L. Fosburgh also relocated to Maynard to supervise work already in progress there on the woolen mill being built by his construction firm. Mrs. Robert L. Fosburgh, along with daughters Esther and Beatrice, went on to St. Clair, Michigan, to visit Mrs. Fosburgh's parents, Mr. and Mrs. Stuart, for "an indefinite period." The family apparently never returned to the Berkshires.

The R.L. Fosburgh and Son Construction Company ended its presence in Pittsfield before completing its building contracts at the Stanley Works. Still, the project rapidly moved on to completion. The main factory building was utilized for the building of transformers and measured five hundred by ninety feet in dimension. By the end of 1901, some 1,200 company workers occupied the site, which grew to include several supplementary buildings. Close to $1 million in products were shipped that year. It was during this period that more than five hundred Stanley-built generators were in use in the United States and Canada.

The evening of the very day that Robert S. Fosburgh was acquitted, Dr. Franklin Kittredge Paddock, a major defense witness and medical examiner of Berkshire County, died. A close friend stated, "The House of Mercy owes more to Dr. Paddock than any other man living or dead. The work he did for the poor and unfortunate cannot be underestimated in value or scope. The amount of charity work he did was remarkable." Though he testified in obviously poor health, it was said that "he showed a commendable disposition throughout to be perfectly fair and to utter all the truth that was in him." The following is an excerpt of an obituary delivered to fellow medical directors:

Dr. Frank Kittredge Paddock's grave marker at Pittsfield Cemetery. *Photograph by Frank J. Leskovitz.*

> *Dr. Paddock was born in Hamilton, New York on December 19, 1841 and had therefore nearly completed his sixtieth year at the time of his death. Thirty-six of these years were spent in active practice in Pittsfield, and his success was so marked that it may justly be claimed for him that for the twenty years prior to his death he was the most eminent physician and surgeon*

in Western Massachusetts. Dr. Paddock was a rare man, one of those men who inspire confidence and affection. Possessed of that foundation of all intellectual excellences, a retentive memory, he was remarkable for quickness and accuracy of perception. Perhaps his most marked characteristics were his unflagging industry and mental and physical endurance. He did the work of two men from early morning to late into the night, day after day, year after year, and this was the more remarkable when we consider he suffered all his life, from the age of sixteen years, with serious valvular disease of the heart, a condition which finally brought about his death.

It was said that outside of the Berkshire County Superior Court, Dr. Paddock never expressed an opinion regarding the Fosburgh case.

Chief Nicholson filed the following official report with the City of Pittsfield:

The department was notified that the residence of Mr. Robert L. Fosburgh was entered by three men, and that his daughter, Miss May L. Fosburgh, had been shot and killed in the house, on the night of August 20th, A.D. 1900. This residence is situated at the junction of Tyler Street and Dalton Avenue, which is in the outlying residential portion of the city. Captain White and Officers Chapman and Flynn responded at once, and every member of this Department was immediately detailed on the case, to properly cover and search the entire city, and the surrounding territory, it was deemed advisable to send out a general fire alarm from Box 42, which, at the request of the Department, the Chief Engineer very promptly did, thus placing at the disposal of the Police Department for immediate service, in any part of the city, a large number of experienced men, a number of whom were Special Police Officers. As these men had a good knowledge of the city and its environments, and also knew what to do in such an emergency, their service was most valuable, and was very faithfully and efficiently performed, in addition to the personal efforts of the officers and members of the Fire Department, the horses and wagons available under their charge were placed at the disposal of the Police Force for the transportation of the officers and citizens engaged in the patrol duty which was being constantly performed. The assistance of the Sheriff, Mr. Charles W. Fuller, and his deputies, was rendered the city; and Deputies Fish, White, Reynolds, and Richards remained continuously on the case until the search about the city and county was abandoned. These officers were most thorough and painstaking in all of their efforts in behalf of the Department. This valuable service was rendered the city gratuitously by these deputies,

who also furnished their own means of transportation. I would therefore respectfully recommend that in addition to thanking them, all cost which they may have necessarily incurred be paid to them. His Excellency, the Governor of this Commonwealth, W. Murray Crane, immediately notified this Department that the Chief of the Massachusetts District Police, Mr. Rufus R. Wade, would furnish the city such force as would be necessary, who could give their undivided attention to the case. The Chief was respectfully informed at once, that any assistance he could provide would be necessary and greatly appreciated by the city authorities; whereupon four District Police Officers were promptly detailed to report to this office for duty, consisting of Moses H. Pease, James McKay, Jephanus H. Whitney and George Dunham. Officer George C. Plant was also detailed, but was unable to co-operate in this case because his services being immediately required in his district. These officers having had a long and successful experience in criminal investigations, were very thorough in the discharge of their duties in this case, and have rendered the city excellent and skillful service. The co-operation of the Pinkerton Detective Agency was also obtained, and their usual good service, for which they are so well known, was faithfully performed. The means for the payment of this Agency was provided by a gentleman who is interested in the welfare of the city. It can be confidently stated that all information obtained in regard to any and all suspicious persons known to have been in this vicinity was most carefully investigated and their whereabouts on the night of August 20th satisfactorily determined. In response to a call for volunteers issued by the press of the city to assist the officials in the search already instituted, the services of a sufficient number of citizen was offered to enable us to completely cover the many avenues of escape and keep them constantly patrolled, and also to keep guarded the highways in all towns adjoining the city. The employees of the railroad companies also joined the citizens in their efforts to aid the department, and also furnished the Officers and transportation available when necessary. During the time [the] search was continued between five and eight hundred citizens were almost constantly engaged, and upwards of two thousand persons were waiting in the streets at the station for an opportunity to render some assistance. This was indeed a great inspiration to every officer engaged in this case and also a splendid example of good citizenship. To these gentlemen and to the members of the press of this city is due the sincere thanks of the Police Department, for the prompt and necessary assistance which was so cheerfully given the officers in this emergency. The city is indebted to the Chief and Members of the State

Department, to the Chief Engineer and Members of the Fire Department, and to the Chief of Police and Police Officers in the several cities and towns for their services. All requests for information and assistance were promptly and courteously complied with. I desire to especially commend Captain W.G. White and the Officers of the Department, for the excellent service performed in this case, which was promptly and cheerfully rendered at all times, being deprived of the necessary rest these officers made every effort to accomplish the best results possible, the extra duty, together with their regular service, was performed with careful attention to every detain, and was rendered to the city without extra compensation, the usual good discipline was maintained.

Most Respectfully Submitted, Your Obedient Servant, John Nicholson, Chief of Police, City of Pittsfield.

Pittsfield police chief Nicholson's local popularity did not wane after the Fosburgh trial. In 1905, Massachusetts governor William L. Douglas appointed Chief Nicholson to the office of high sheriff of Berkshire County. He would be routinely reelected to this office, serving as sheriff until 1932, the year he died from a heart attack. Coincidentally, Chief Nicholson's wife's first name was May.

Robert S. "Bert" Fosburgh and Amy Jane Sloan Fosburgh had a daughter on February 21, 1903, in Portsmouth, New Hampshire. They named her Helen May Fosburgh. In June 1909, Amy Fosburgh sued her husband, Robert S. Fosburgh, for divorce, alleging cruelty. It is believed that the divorce was never finalized. On January 18, 1916, Robert S. Fosburgh died at the Hotel Virginia in Long Beach, California. His death was attributed to cirrhosis of the liver. He was forty-four years old. His early death is another sad piece of the story. Amy Fosburgh lived for some thirty years with her parents in Duluth, Minnesota, before moving to Pima, Arizona. It is believed that she had no further contact with the Fosburgh family. She was remembered as a "caring, lovely little lady who wouldn't hurt a flea." Amy died in 1949 at age seventy-three. She never remarried.

Sisters Esther and Beatrice Fosburgh each attended Dana Hall School in Wellesley, Massachusetts, and later finishing school in Paris, France, where they were instructed in proper social graces believed necessary for successful entry into upper-class society. Esther Lyall Fosburgh married Dr. Dudley Morton, a surgeon, in New York City in 1911. Her sister Beatrice was maid of honor, and her brother James served as best man. Robert S.

Sisters Beatrice and Esther Fosburgh. *Photograph from the personal collection of Beatrice Lynn Wilde.*

Fosburgh was not in the wedding party. Esther and Dr. Morton went on to have two children. By this time, James B.A. Fosburgh was married to Leila W. Whitney and working as an engineer in Manhattan, New York. They had two children together. Leila died on April 13, 1913. James remarried his late wife's younger sister Eleanor Newton Whitney, and they would have two additional children together. James B.A. Fosburgh died on March 3, 1926, and Eleanor followed on April 24, 1930. Beatrice Alexandra Fosburgh wed Charles Angelo Moore. Their union produced four children but ended in divorce in 1929. Her ensuing years were said to have been financially difficult. Beatrice passed away on September 2, 1972, at eighty-six years of age. She and her sister Esther remained very close throughout their lives.

In the 1910 United States census, family patriarch Robert Lloyd Fosburgh listed his occupation as a stock broker in New York City. He died just a few days after his son Robert S. Fosburgh on January 29, 1916. His wife, Esther Mair Stuart Fosburgh, would follow on December 18, 1928.

Miss Bertha Louise Sheldon, the only non-family member in the Fosburgh home the night of the tragedy, married James B. Barrett in 1916. Barrett worked as a treasurer in the hotel industry, and the couple lived for many years in Cranston, Rhode Island.

In 1950, the Castle house, or the Fosburghs' "House of Mystery," was demolished to make way for a Sun Oil gasoline station. At the time, the Pittsfield City Council vote to demolish the dilapidated structure was

An automotive glass shop is currently located at the site of the murder. *Photograph by Frank J. Leskovitz.*

The Stanley Electric Manufacturing Company site as it appears today. *Photograph by Frank J. Leskovitz.*

unanimous in order to allow the city to "get rid of that awful place." Today, an automotive glass replacement company is located on the site.

William Stanley's electric works became the predecessor of corporate giant General Electric. In 1903, General Electric absorbed Stanley's business and became the major employer in the area. The General Electric transformer division, along with its ordnance and plastics divisions, would all find homes within the city. GE would close the transformer division in Pittsfield for good in 1986, and mass layoffs resulted. At its heyday, General Electric employed some thirteen thousand people in Pittsfield.

The decline in manufacturing that occurred throughout New England hit the area hard, and Pittsfield still struggles today to redefine itself. Several remaining mill buildings in the area have been converted into housing, storage units or artist space. Many others that still exist are in a sad state of disrepair. The buildings that once made up the Stanley Electric Works have been razed, and the city has hopes of redeveloping the site. Despite its difficulties, several publications have named the city of Pittsfield a top place to live.

May Lydia Fosburgh is buried alongside her parents in Woodlawn Cemetery in Bronx, New York. Nearby are the graves of her siblings Beatrice

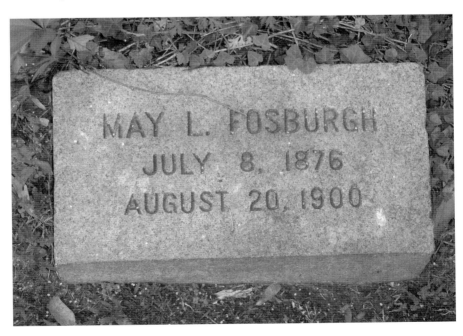

May L. Fosburgh's grave marker at Woodlawn Cemetery in the Bronx, New York. *Photograph by Maryann Byrnes.*

and James. A simple rectangular granite stone marks her final resting place. A larger marker to the rear of the plot displays the Fosburgh name. The cemetery bears the same name as the street alongside the house in Pittsfield, Massachusetts, where May Fosburgh lost her life.

Death

Before us great Death stands
Our fate held close within his quiet hands.
When with proud joy we lift Life's red wine
To drink deep of the mystic shining cup
And ecstasy through all our being leaps—
Death bows his head and weeps.

Rainer Maria Rilke

The Cast of Characters

Aiken: Judge John A. Aiken, Greenfield, Massachusetts, signed arrest warrant
Bagg: Allen H. Bagg, employee of Peirson Hardware
Barnes: Edwin F. Barnes, Fosburgh trial jury foreman
Bennett: J. Gorden Bennett, Dr. Walter W. Schofield's driver
Beverly: Mrs. Nellie Beverly, trial witness
Bridges: George Bridges, manager, Hanan & Son shoe store, New York City
Bristol: Miss Mary Bristol, stenographer at the inquest into the death of May L. Fosburgh
Bullard: Mrs. Bertha E. Bullard, trial witness, neighbor
Burns: James M. Burns, bail bondsman
Calkins: Reverend Raymond Calkins, pastor, Pilgrim Memorial Church, Pittsfield, Massachusetts
Callahan: John Callahan, trial witness
Cande: Frank H. Cande, Berkshire County Clerk of Courts
Castle: Mrs. E.T. Castle, owner of the Fosburgh residence
Chapin: Miss M. Estelle Chapin, trial witness, neighbor
Chapman: Officer George E. Chapman, Pittsfield Police Department
Colt: Dr. Henry Colt, assistant medical examiner of Berkshire County
Connor: John P. Connor, Pinkerton detective
Crosby: Attorney John C. Crosby, attorney for the prosecution, former mayor of Pittsfield
Dean: Officer James F. Dean, Pittsfield Police Department
Draper: Dr. Frank Draper, medical examiner of Suffolk County

Left: May L. Fosburgh sketch, dated July 25, 1901. *From the* Idaho Statesman.

Right: Robert S. Fosburgh sketch, dated July 25, 1901. *From the* Idaho Statesman.

Dunn: William Dunn, trial witness

Flynn: Officer Daniel P. Flynn, Pittsfield Police Department

Fobes: Arthur A. Fobes, Pittsfield city engineer

Fosburgh: Amy Jane Sloan Fosburgh, wife of the defendant, Robert S. Fosburgh; Beatrice Alexandra Fosburgh, sister of May L. Fosburgh; Esther Lyall Fosburgh, sister of May L. Fosburgh; Esther Mair Stuart Fosburgh, matriarch of the Fosburgh family, wife of Robert L. Fosburg; James Boies Alleyne Fosburgh, brother of May L. Fosburgh, student at Yale University; May Lydia Fosburgh, eldest daughter, shot and killed under questionable circumstances; Robert Lloyd Fosburgh, patriarch of the Fosburgh family, owner of R.L. Fosburgh and Son Construction Company; Robert Stuart "Bert" Fosburgh, eldest son and suspect in the death of May L. Fosburgh

Frey: Deputy Sheriff George H. Frey, search party leader

Gardner: District Attorney Charles L. Gardner, district attorney from Berkshire County; William R. Gardner, trial witness, neighbor, assistant manager, Pittsfield Electric Light Co.

Gray: William Lewis Gray, suspect

Hall: Nelson James Hall, trial witness

Hammond: District Attorney John Chester Hammond, district attorney from Suffolk County, Massachusetts

Hayes: James Hayes, trial witness

Hazen: William E. Hazen, former chief of the United States Secret Service

Hibbard: Attorney Charles E. Hibbard, attorney for the defense, former and first mayor of Pittsfield, Massachusetts

Hollistor: Joseph W. Hollistor, reporter

Holmes: Reverend S.V.V. Holmes, pastor, Westminster Presbyterian Church, Buffalo, New York

Hopkins: Harold W. Hopkins, trial witness

Joyner: Attorney Herbert C. Joyner, attorney for the defense

Loyd: Deputy Sheriff William L. Loyd, search party leader

Lund: Frederick W. Lund, paymaster and bookkeeper, R.L. Fosburgh and Son Construction Company

McKay: James McKay, detective, Massachusetts State Police

Mills: Arthur A. Mills, bail bondsman

Nicholson: Chief John Nicholson, Pittsfield Police Department

Noble: Frank J. Noble, trial witness, employee, Pittsfield Electric Light Co.

Paddock: Dr. Franklin Kittredge Paddock, key trial witness, medical examiner of Berkshire County

Parker: Detective Patrick Parker, Providence, Rhode Island Police Department

Peirson: Frank E. Peirson, trial witness, hardware merchant

Plumb: Mr. and Mrs. Harry S. Plumb, trial witnesses, neighbors

Plunkett: William B. Plunkett, owner, Berkshire Cotton Manufacturing Company, Adams, Massachusetts

Pryer: Judge Roger A. Pryer, New York Court of Appeals

Quinn: Michael "Dirty Dick" Quinn, alleged suspect

Rose: William H. Rose, trial witness, Boston, Massachusetts firearm company employee

Russell: Hezekiah S. Russell, mayor of Pittsfield

Schofield: Dr. Walter W. Schofield, first outside witness and doctor at the scene

Sedden: William Walter Sedden, salesman, Hanan & Son shoe store, New York City

Sheldon: Frank Perry Sheldon, father of Miss Bertha L. Sheldon; Miss Bertha Louise Sheldon, Fosburgh houseguest from Providence, Rhode Island

Shepardson: James P. Shepardson, trial witness, neighbor; May C. Shepardson, trial witness, neighbor

Smith: Frederick S. Smith, trial witness, civil engineer

Stevens: Judge William B. Stevens, Fosburgh trial judge from Boston, Massachusetts

Taylor: Attorney Seneca Newberry Taylor, Fosburgh family friend from St. Louis, Missouri

Titus: Captain George F. Titus, chief detective, New York City Police Department

Tucker: Judge Joseph Tucker, headed the official secret inquest proceedings

Walsh: Mary Walsh, trial witness, Fosburghs' washwoman

Wheeler: Sheldon S. Wheeler, trial witness, photographer

White: Captain William G. White, Pittsfield Police Department

Whitney: General Jephanus H. Whitney, Massachusetts State Police

BIBLIOGRAPHY

NEWSPAPER ARTICLES

Berkshire Evening Eagle. "Another Clue in Fosburgh Case." July 26, 1901.

———. "Beatrice Saw Pillow Case Head of Burglar." July 24, 1901.

———. "Brutal Murder Committed in the Early Morning." August 20, 1900.

———. "Date Set for Fosburgh Trial." July 8, 1901.

———. "District Attorney Stands by Chief Nicholson." January 30, 1901.

———. "Dr. F.K. Paddock Is dead." July 27, 1901.

———. "End of Fosburgh Trial." July 31, 1901.

———. "Family Leaving Pittsfield." July 27, 1901.

———. "Fosburgh Breaks His Silence." January 29, 1901.

———. "Fosburgh Released on Bail." January 28, 1901.

———. "In Behalf of the Defendant." July 25, 1901.

———. "James B.A. Fosburgh Takes the Stand." July 22, 1901.

———. "May Fosburgh, the Dead Girl." July 18, 1901.

———. "Miss Fosburgh Slayer Has Not Been Found." August 21, 1900.

———. "Mrs. R.L. Fosburgh to Testify for Defense." July 20, 1901.

———. "Nothing New in Fosburgh Case." January 31, 1901.

———. "Officer Dan Flynn Asks 'Whose Shoe Is This?'" July 23, 1901.

———. "Only for Three Hours." July 27, 1901.

———. "Police Make Arrest in Fosburgh Murder Case." January 26, 1901.

———. "Rhode Island Girl Saw May Lying Dead." July 25, 1901.

———. "R.S. Fosburgh's Trial Ends in Aquital." July 26, 1901.

———. "The Test Exhibits Now in Evidence." July 19, 1901.

———. "Touching Obsequies for Miss Fosburgh." August 22, 1901.

———. "What Defendant's Brother Told." July 24, 1901.

———. "Will Wait 'Till July Term." February 1, 1901.

Berkshire Sunday Record. "Prominent Men of Pittsfield." June 10, 1894.

Idaho Statesman. "Remarkable Murder Case in Massachusetts." July 21, 1901.

New York Times. "After Fosburgh Suspect." July 26, 1901.

———. "Chief Titus Approves Fosburgh Acquittal." July 27, 1901.

———. "Fosburgh Defense Ended." July 26, 1901.

———. "Fosburgh Defense Opens." July 25, 1901.

———. "Fosburgh Family Relations." July 22, 1901.

———. "Fosburgh Is Acquitted." July 27, 1901.

———. "Fosburgh's Brother an Aid to Defense." July 23, 1901.

———. "Fosburgh Trial July 18th." July 9, 1901.

———. "Fosburgh Trial Today." July 18, 1901.

———. "Gray Gives Himself Up." July 27, 1901.

———. "Gruesome Evidence in the Fosburgh Trial." July 20, 1901.

———. "Justice According to the Law?" July 27, 1901.

———. "Justice According to the Law?" October 15, 1911.

———. "Prosecution Rests in the Fosburgh Case." July 24, 1901.

———. "R.S. Fosburgh Placed on Trial." July 19, 1901.

———. "Story of the Tragedy." July 19, 1901.

———. "The Trial of R.S. Fosburgh." July 14, 1901.

San Francisco Call. "The Killing of Miss May Fosburgh a Remarkable Criminal Mystery." February 4, 1901.

WEBSITES

"Family Search: Fosburgh." Ancestery Library Edition. www.ancestrylibrary. com (accessed January 16, 2015).

"The Inflation Calculator." The Inflation Calculator. http://www.westegg. com/inflation (accessed January 28, 2015).

BOOKS

Boltwood, Edward. *The History of Pittsfield, MA: From the Year 1876 to the Year 1916*. Pittsfield, MA: Eagle Printing and Binding, 1916.

City of Pittsfield. *Annual Reports: City of Pittsfield*. N.p.: Sun Printing Company, 1901.

———. *Pittsfield Directory*. N.p.: Eagle Publishing Company, 1900.

Fosburgh, Lacey. *Old Money*. New York: Doubleday, 1983.

Foster, E. Everton. *Lamb's Textile Industries of the United States*. N.p.: James H. Lamb Company, 1916.

Henry, C.C., and L. Blain. *Industrial Edition: Evening Eagle: 1897 & 1898*. N.p.: Eagle Publishing Company, 1898.

Jones, Robert. *Forensics 101: A Friendly Primer for Writers*. N.p.: Macabre Ink, 2010.

Lamont, Jessie. *The Poems of Rainer Maria Rilke*. N.p.: Press of Tobias A. Wright, 1918.

Lawrence, D.H. *New Poems*. N.p.: Martin Secker, 1918.

Marquis, Albert Nelson. *Who's Who in New England*. N.p.: A.N. Marquis & Company, 1909.

Owens, Carole. *Pittsfield: Gem City in the Gilded Age*. Charleston, SC: The History Press, 2007.

Reno, Conrad, and Leonard Augustus Jones. *Memoirs of the Judiciary and the Bar of New England: Biographical Massachusetts*. Boston: Century Memorial Publishing, 1901.

Symonds, Brandreth. *An Abstract of the Proceedings of the Life Insurance Medical Directors of America*. Vol. 1. New York: Knickerbocker Press, 1906.

SHEET MUSIC

Bingham, Clifton, and D'Auvergne Barnard. *The Plains of Peace*. N.p.: Bosworth & Company, 1892.

Kipling, Rudyard, and Reginald deKoven, *Recessional*. Cincinnati, OH: John Church Company, 1897.

Weatherly, F.E., and Stephen Adams. *The Holy City*. London: Boosey & Hawkes, 1892.

INDEX

ABOUT THE AUTHOR

Frank J. Leskovitz is a retired dispensing optician and a history buff from Pittsfield, Massachusetts. He enjoys all the Berkshires have to offer with his wife, Linda; daughters, Heidi and Holly; and noisy dachshunds, Gilbert, Moxie and Katie.